Crazy Felt

Using Water-Soluble Stabiliser

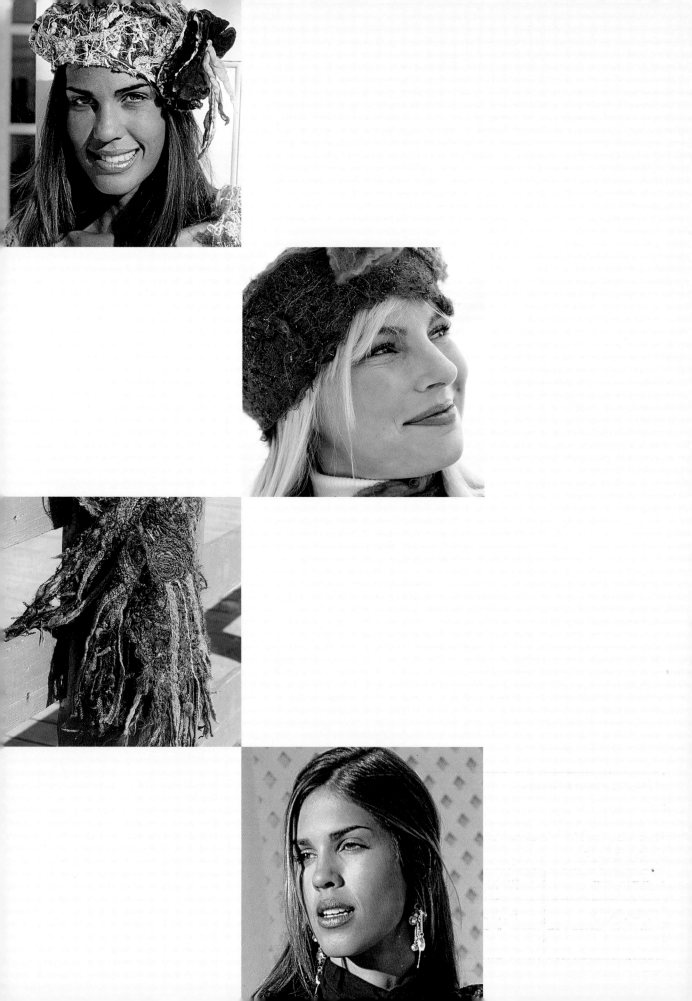

Jeannette Knake

Crazy Felt

Using Water-Soluble Stabiliser

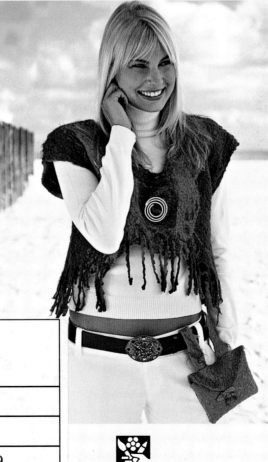

SEARCH PRESS

Jeannette Knake has worked in the handicraft business for many years. Her books *Crazy Patchwork*, *Crazy Wool* and *Crazy Felt* have been published in German and met with great success.

FOREWORD

Dear Readers,

Crazy Felt is a technique that allows you to give free rein to your creativity. It is based on the same methods as Crazy Patchwork and Crazy Wool. With Crazy Felt, wool and special-effect yarns are arranged as you wish on a base material (water-soluble stabiliser) and temporarily attached with a spray adhesive before being stitched in place using a sewing machine. The use of merino or mohair wool together with microfibre and special-effect yarns will result in a unique look. The item is then machine washed on a wool cycle at 30°C and spun at 1000rpm to turn it into felt. You should expect it to shrink by five per cent. The great advantage here is that this five per cent shrinkage results in a full felting

effect – it produces an entirely different look but with very little change in size so that all patterns can be used in their original dimensions.

Crazy Felt forms the basis for fashion designs which will make you feel great – from tops to handbags for both beginners and more advanced users, offering boundless potential for self-expression.

I wish you every enjoyment in designing delightful new garments and trendy accessories.

Jeannette Knake

Publishers' Note

There is a wide range of water-soluble stabilisers on the market, which all give similar results but whose properties, including weight and rinsing method, vary. The garments in this book have all been made using Soluvlies water-soluble stabiliser, manufactured by Freudenberg, and the instructions provided therefore relate to this product. Other types of water-soluble stabiliser can be used instead, but the Publishers recommend that you adjust the instructions given in this book in the light of those provided by the manufacturer.

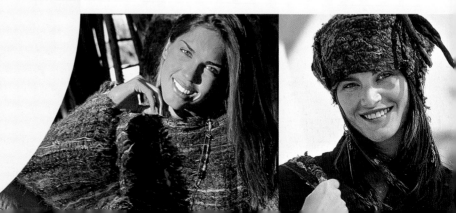

4

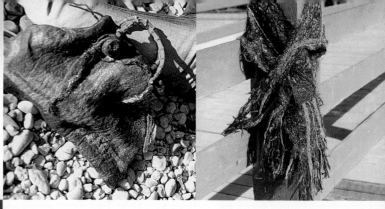

CONTENTS

♦ = *easy* ♦♦ = *average* ♦♦♦ = *more difficult*

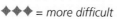

Crazy Felt

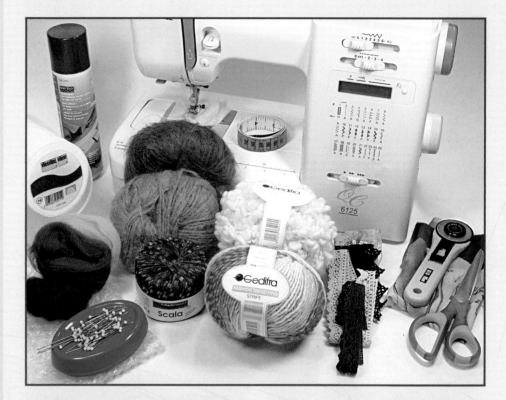

MATERIALS

- firm worksurface
- dressmaking scissors, cutting wheel
- pins, tape measure
- water-soluble stabiliser, e.g. Soluvlies by Freudenberg
- spray adhesive
- sewing machine
- mohair, special-effect yarn, woollen yarn
- fabric, lace trim (braid)

NOTES

Spray adhesive produces a light bonding surface on the stabiliser fabric, making the rest of the work easier with the materials fixed in place. When using the spray adhesive, always hold it around 20cm (8in) away and apply only a very thin layer. If a white coating can be seen after application, you have used too much adhesive. In this case put the item to one side for around 12 hours before continuing work. The humidity in the air will cause the final layer to disappear if left for a while.

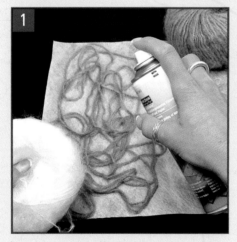

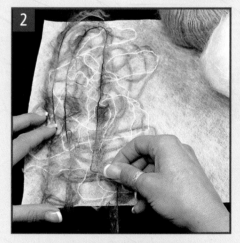

Prepare stabiliser and arrange mohair yarn

Cut out the stabiliser twice to size according to the pattern. Apply a very thin layer of spray adhesive to create an extremely light bonding surface. The second piece of stabiliser will then be used to cover the first later. Arrange the mohair yarn, criss-crossing at random on the stabiliser, and then spray with adhesive between the layers to secure.

Arrange special-effect yarn and spray

Now lay out the special-effect yarn (microfibre) over the mohair. If you want a fringing effect, you can let the yarn extend beyond the edge of the stabiliser. Fix in place by applying another very thin layer of spray adhesive.

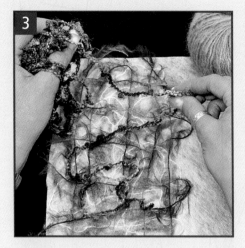

Arrange other yarns

You can now add other yarns, for example glitter yarns. After finishing each layer of yarn, spray very finely again with adhesive between the layers to secure. If no other yarn, fabric or trim is to be added, you can also arrange the decorative layer in a striped or checked pattern.

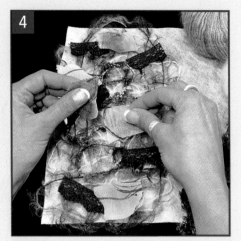

Arrange fabric

Besides yarn you can use lace trim and fabric. Cut the lace trim into strips approx. 5–8cm (2–3in) in length. Cotton, silk and viscose are all equally suitable for the fabric. Cut into squares of around 4 × 4cm (1½ × 1½in) and arrange on the stabiliser. You can also create your own patterns and designs with these fabric squares.

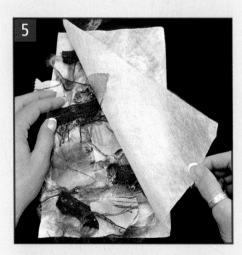

Prepare for stitching

Once you have finished arranging the yarns on your piece of stabiliser, lightly mist over the entire surface once again with adhesive. Place the second piece of stabiliser on top and press down with the palm of your hand. With very large pieces, use pins to fix in place at the corners as well.

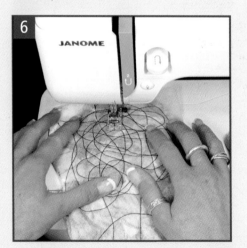

Stitching

Stitch with the sewing machine in a random pattern. Start at any point and stitch over the entire area in circles or criss-cross until there are no remaining empty spaces over 3 × 3cm (1¼ × 1¼ in) in size. Join all pieces together and put in the washing machine on a 30°C wool cycle spinning at a maximum of 1000rpm (see details in right-hand column), unless instructed otherwise.

WASHING

Light felting

When washed on a 30°C wool cycle at a maximum of 1000rpm, the fibres of mohair or special-effect yarn (microfibre) will mat together, resulting in light felting. Here you must expect shrinkage of some five to ten per cent. For this reason you should take careful note of the measurements and patterns of the different designs.

Heavy felting

Heavy felting of mohair and pure new wool with shrinkage of up to 40 per cent can be achieved by washing in the machine at 40°C at a minimum of 1200rpm. Note that the layers of mohair and wool should not be too thick as the felted material will then be too hard and stiff.

TIP

To wash, use a detergent for delicate fabrics or a little fabric conditioner. If the item remains sticky, you have used too much adhesive. Simply add a little fabric conditioner or three tablespoons of vinegar to the rinsing water.

Felting effects and wet felting

NOTE

Using fabric with special-effect yarns on top will make your item look like felt even though felting has not actually taken place. Here the sole purpose of washing is to remove the stabiliser and spray adhesive. The Crazy Felt look is still produced as the fabrics (cotton, silk or viscose) tend to fray during this process. The combination of fringing made of fabric and special-effect yarns results in this highly attractive felted look. You need not expect any shrinkage here.

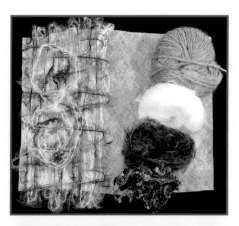

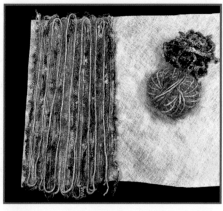

MATERIALS FOR WET FELTING
• thin sheeting, bubble-wrap
• soft soap
• large towel, string or cord (only for piece felting)
• felting wool

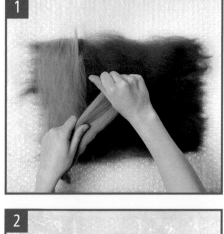

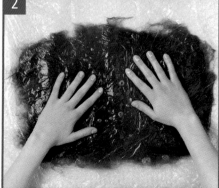

Felting effect with mohair yarn

Here you can see how mohair has been combined with special-effect yarn (microfibre). It is important to make sure you always lay out the mohair yarn on the stabiliser first or the Crazy Felt effect will not be produced afterwards. When washed, the mohair yarn forms a light felt-effect surface, so creating the special felted look.

Yarns need not just be arranged at random. Here a pattern has been created with strands of mohair and special-effect yarns, with special-effect yarn then being laid on top in a figure of eight.

Felted look without felting

Yarns can also be arranged side by side. Here fluffy special-effect yarn (microfibre) has been combined with glitter yarn. Although no mohair has been used and felting does not take place when washed later on, the interaction of the two types of yarn creates a felted look without felting.

Piece felting

1. To make the bags shown on pages 30 and 32 you first have to felt individual pieces. To do so, spread out the bubble-wrap and arrange three layers of felting wool crosswise over an area of the specified size. Wet the wool with hot soapy water.

2. Place a piece of thin sheeting on top and rub gently with your hands to bring about light felting. Once the wool has become firmer, roll in a towel. Tie the ends of the roll and put it in a tumble dryer for 20 minutes to felt the item. Remove and continue work.

Using a dryer reduces the felting time enormously. If you do not have a dryer, you can put the roll of wool in your washing machine at 40°C and spin at approx. 1200rpm.

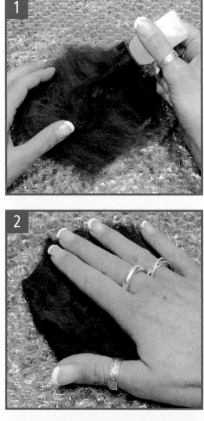

Felting flowers

1. Spread out bubble-wrap to make a worksurface. Arrange six thin layers of felting wool crosswise. Do not forget that there may be shrinkage of up to 40 per cent when working out the number of layers and the size of the piece of wool. Wet the wool you have arranged on the sheet using hot soapy water.

2. Press the wool into the liquid with the palm of your hand and rub for around two minutes using a circular motion (felting).

3. Place the wool in your palm and roll between both hands as if making a ball of material. This will make the wool turn to felt more quickly, and the flower will shrink by up to 40 per cent.

4. Use your thumb to fashion a flower out of the wool and allow to dry.

Such modelling produces the final form, allowing you to create leaves or other small objects.

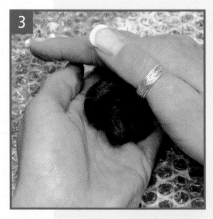

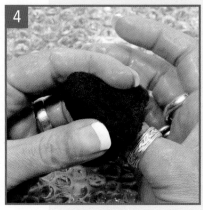

Felting strands

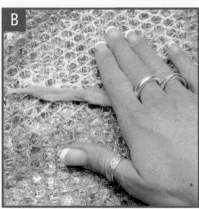

A. Spread out bubble-wrap to make a worksurface. Arrange six thin layers of felting wool in a strand approx. 20cm (8in) in length. With strand felting the wool fibres are arranged in very thin layers, not crosswise but lengthwise, layered one after the other.

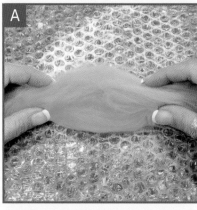

B. Wet the wool with hot soapy water and roll backwards and forwards on the sheeting with the palm of your hand for about two minutes. When doing so, make sure that the strand does not become too dense or hard in the middle so that it will be easier to sew on by hand later on.

A modern romantic look

This shawl and beret ensemble looks bright and feminine. Not just for romantics – its charm has a practical appeal as well.

Unusual extra features such as this felt flower are not difficult to make yourself.

Beret
Size
Circumference of head
56–60cm (22–23½in)
Level of difficulty
◆

Shawl
Size
approx. 190cm (74¾in) long,
15–30cm (6–12in) wide
Level of difficulty
◆

MATERIALS

Both designs
- 'Serano' by Gedifra (52% polyamide/Tactel, 48% polyamide; length approx. 100m (109½yd)/50g): 50g in light pink
- 'Capriola' by Gedifra (70% pure new wool, 20% polyacrylic; length approx. 30m (33yd)/50g): 50g in lilac-pink-rose
- 'Spicco' by Gedifra (44% pure new wool, 44% polyacrylic, 12% polyester; length approx. 35m (38yd)/50g): 100g in pink, 50g in blackberry
- mohair yarn, e.g. 'Belisana' by Gedifra (70% kid mohair, 15% wool, 15% polyamide; length 115m (126yd)/50g): 100g in white, 100g in pink
- spray adhesive
- sewing thread in pink and blackberry
- pins, scissors

Beret
- cotton lace trim in pink, 1cm (½in) wide, 1m (39½in)
- water-soluble stabiliser, 60 × 90cm (23½ × 35½in), e.g. Soluvlies by Freudenberg (for 4 circles each 34cm (13½in) in diameter)
- sewing needle
- felting wool, 5g each in pink, red and blackberry
- materials for wet felting (see page 8)

Shawl
- water-soluble stabiliser, 200 × 70cm (78¾ × 27½in), e.g. Soluvlies by Freudenberg

For the beret you should expect to use between 15 and 20g of each yarn, with the remaining material being sufficient for the shawl.

INSTRUCTIONS

Beret
1. First take the water-soluble stabiliser and cut out four circles of equal size each measuring 34–36cm (13½–14¼in) in diameter.
2. For the top section of the beret apply a very thin layer of spray adhesive to the stabiliser to produce a light bonding surface. Arrange the yarns at random as shown in Foundation Course I (page 6), starting with the mohair. Before adding further layers of yarn, also spray very lightly with adhesive in between the layers to secure them.

3. For the final layer, the decorative finish, use sections of lace trim around 5 to 8cm (2–3in) in length. Mist over the completed section once again with the spray and apply the second layer of stabiliser, pressing down with the palm of your hand.
4. Prepare the bottom section of the beret in the same way.
5. Stitch over the entire area with the sewing machine in circles or criss-cross at random until there are no empty spaces over 2 × 2cm (¾ × ¾in). Use a pin to mark the right side.
6. Now put the two sections of the beret right sides together and stitch all round with the sewing machine. Add another line of stitching in a narrow zigzag (stitch size 6, stitch width 1).
7. To create the Crazy Felt look now put the beret in the washing machine on a 30°C wool cycle, spinning at 1000rpm and then allow to dry.
8. Once the item has dried, cut out a circle around 25cm (10in) in diameter from one section of the beret. You can also position a medium-sized plate in the middle as an aid here. Mark round the plate and cut out. Try on the beret and enlarge the opening by another 1cm (½in) if necessary.
9. Make a large flower as described in foundation course II (page 9), fashioning stamens out of long strands of material, and sew on to the beret.

Shawl
1. Divide the water-soluble stabiliser into two sections each measuring 35 × 200cm (13¾ × 78¾in).
2. Lay out one section and apply spray adhesive very finely to produce an extremely light bonding surface. Arrange the yarns at random (see photograph on right). Before adding further layers of yarn, spray very lightly with adhesive in between to secure.
3. After the final layer, mist over with a fine layer of adhesive again. Place the second section of stabiliser on top and press down with the palm of your hand.
4. Stitch over the piece of work with the sewing machine in circles or criss-cross at random until there are no empty spaces over 2.5 × 2.5cm (1 × 1in).
5. Finally put the shawl in the washing machine on a 30°C wool cycle, spinning at 1000rpm and allow to dry.

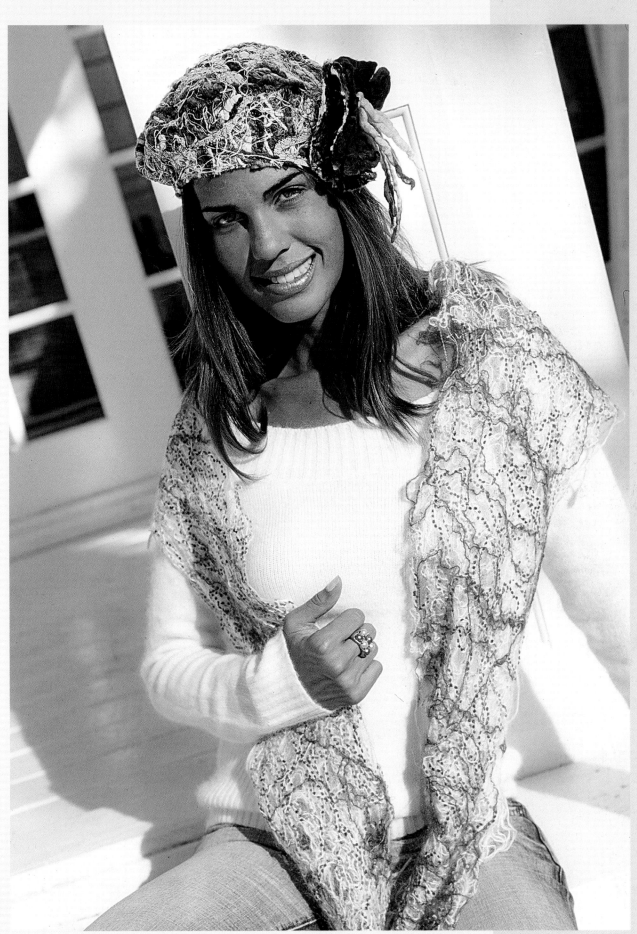

A chic eye-catching feature: the different shades of blue are reflected by a rhinestone brooch.

Denim skirt
Size
10–12 (US 8–10)
Level of difficulty
◆

Denim bag
Size
40 × 35 × 9cm
(15¾ × 13¾ × ½in)
Level of difficulty
◆ ◆ ◆

Blue harmony

This cool duo belongs in everyone's wardrobe – it could become your favourite outfit when combined with a fashionable romantic-style blouse and boots. The Crazy Felt look is created by combining fabric with special-effect yarn – without any need for felting.

MATERIALS

Both designs
- spray adhesive, sewing thread in black
- pins, scissors

Denim skirt
- jeans or a denim skirt (long or short) in your size
- fancy special-effect yarn (with fringes, bobbles, etc.; length approx. 50m (54½yd)/50g): 50g in blue-black
- denim fabric with rose pattern, 220 × 40cm (86½ × 15¾in)
- plain denim fabric, 120 × 40cm (47¼ × 15¾in)
- blue patterned georgette, 20 × 120cm (8 × 47¼in)
- blue-black organza, 20 × 120cm (8 × 47¼in)
- blue cotton lace trim, 3cm (1¼in) wide, 3m (3¼yd)
- black elastic, 2cm (¾in) wide, 3.4m (4yd)
- clear elastic, 3cm (1¼in) wide, 2m (2yd)
- water-soluble stabiliser, 200 × 90cm (78¾ × 35½in), e.g. Soluvlies by Freudenberg

Denim bag
- fancy special-effect yarn (see denim skirt): 50g in blue-black
- denim fabric with rose pattern, 250 × 140cm (99 × 55in)
- plain denim fabric, 60 × 40cm (23½ × 15¾in)
- blue patterned georgette, 10 × 120cm (4 × 47¼in)
- blue-black organza, 10 × 120cm (4 × 47¼in)
- blue-grey patchwork fabric (block-colour look), 60 × 120cm (23½ × 47¼in)
- blue cotton lace trim, approx. 3cm (1¼in) wide, 1.5m (1½yd)
- black elastic, 2cm (¾in) wide, 1.5m (1½yd)
- clear elastic, 3cm (1¼in) wide, 50cm (19¾in)
- water-soluble stabiliser, 60 × 90cm (23½ × 35½in), e.g. Soluvlies by Freudenberg, sewing needle
- 1 pair of handles in black
- rhinestone brooch

INSTRUCTIONS

Denim skirt

1. For the first and third tiers of the skirt cut out around 100 squares measuring 4 × 4cm (1½ × 1½in) from all fabrics as well as the water-soluble stabiliser according to the pattern (see page 40).

2. Apply spray adhesive to the first strip of stabiliser. Arrange the squares of fabric on it and spray to secure, followed by 5–8cm (2–3in) lengths of lace trim and finally the yarn. Mist over with a fine layer of adhesive and cover with the second piece of stabiliser. Stitch over this section at random as described in foundation course I (page 7). Make the third tier of the skirt in the same way.

3. For the second tier of the skirt cut a strip measuring 22 × 160cm (8¾ × 63in) from the fabric with the rose pattern. On the wrong side sew on a piece of clear elastic 2cm (¾in) from the top edge of each piece, stretching it to make gathers.

4. Cut off the bottom of the denim skirt or jeans and stitch the first tier of the skirt to the bottom edge, followed by the second and third tiers.

5. Cut off a piece of black elastic 15cm (6in) long. On the wrong side of the fabric sew it on to the front of the skirt in the middle over a gathered length of 30cm (12in), thus producing vertical gathers. Wash skirt.

Denim bag

1. Cut out all parts according to the dimensions in the pattern (see page 40) as well as 30 squares measuring 4 × 4cm (1½ × 1½in) from all fabrics.

2. Prepare the stabiliser for the Crazy bag as for the skirt (see step 2).

3. Prepare the pieces of fabric you have cut out. Lay out the two carry straps right sides together, stitch and turn right side out. Place the pieces cut for the inner bag right sides together and stitch up to the top edge, leaving an opening of around 15cm (6in) in a side seam to turn. Stitch the Crazy bag to an outer section of the bag at the bottom. Put the outer sections of the bag right sides together and stitch up to the top edge. Turn right side out.

4. Place the bag strips right sides together, stitch and pull through the bag handles, attaching each handle to the top of the bag using two bag strips.

5. Insert the outer bag in the inner bag right sides together. Insert the carry straps between the outer and inner bag sections at a distance of approx. 10cm (4in) (from bag strips) and pin. Stitch round the top edge of the bag to close and turn right side out through the opening in the inner bag. Stitch up the opening.

6. Place the strip of fabric for the rose right sides together and stitch a side seam. Turn and stitch along the edge. Gather the strip and fashion into a rose. Sew on to the front of the bag in the middle.

7. Finally wash the bag and allow to dry. Finish off by attaching the rhinestone brooch.

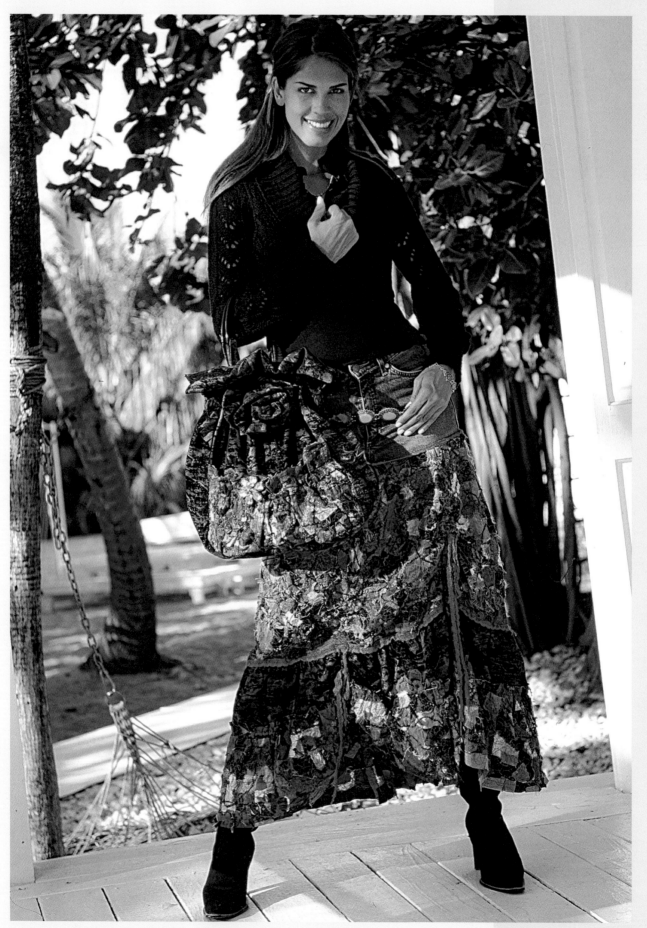

Practical yet unusual: the buttons are also positioned at random and sewn in place.

Loose-fitting cape

Size
12–20 (US 10–18)
Level of difficulty
◆◆◆

Get swinging with buttons

Here you will make a lovely warm cape. You can also brighten up an old poncho or a favourite jacket that has become dated. With a jacket, just undo the sleeve and side seams and insert gussets made of Crazy Felt.

MATERIALS

- spray adhesive
- sewing thread in black and blue
- pins, scissors
- boiled wool in denim blue, 300 × 120cm (118 × 47¼in)
- 'Sheela' by Gedifra (48% pure new wool, 48% polyacrylic, 4% polyamide; length approx. 30m (33yd)/50g): 100g in blue-lilac-green, 50g in pastel blue
- mohair yarn (with a high mohair content; length between 80m (87½yd) and 125m (137yd)/50g): 100g in turquoise
- fancy special-effect yarn (with fringes, bobbles, etc.; length approx. 50m (54½yd)/50g): 100g in blue-black
- water-soluble stabiliser, 200 × 90cm (78¾ × 35½in), e.g. Soluvlies by Freudenberg

INSTRUCTIONS

1. For the cape cut out two pieces of the boiled wool according to the pattern (page 41), placing the template on the fold of the fabric. Cut the front section right through in the middle. Also cut out two pieces of water-soluble stabiliser for the Crazy strip edging for the cape, according to the pattern.

2. Lay out the first section of stabiliser and apply spray adhesive very finely. Arrange the mohair yarn on it at random as described in foundation course I (page 6). Spray to secure and add other yarns in a random pattern. Cut out several pieces of boiled wool measuring approx. 2 × 12cm (¾ × 4¾in) and insert between the wool.

3. Mist over the piece of work with a fine layer of adhesive again. Cover with the second layer of stabiliser and press down.

4. Stitch with the sewing machine in circles or criss-cross until there are no remaining empty spaces over 2 × 2cm (¾ × ¾in).

5. Now, in a change from the usual procedure, wash the Crazy strip (put in the washing machine on a 30°C wool cycle at 1000rpm) before continuing work. Allow to dry.

6. Pin the Crazy strip all around the cape and stitch in place.

7. For the buttons cut out five circles of boiled wool 8cm (3in) in diameter. Arrange yarn at random and stitch in place in the middle. On the right-hand side of the cape sew on five loops of boiled wool measuring 1 × 24cm (½ × 9½in) with the sewing machine. On the other side of the cape pin the buttons in position and stitch in place.

8. For the collar, cut out a piece of boiled wool measuring 10 × 60cm (4 × 23½in) and adjust to the required collar size using seven darts. Place right sides together and sew to the top of the cape.

TIP

The following applies to all Crazy work: Whenever there is still a seam to be made, the water-soluble stabiliser has to remain in place. It acts as the backing for the yarns and fabrics and ensures that the joined yarns are conveyed under the foot and drop feed of the sewing machine. However, this design is an exception, with the Crazy strip being washed before it is stitched to the cape.

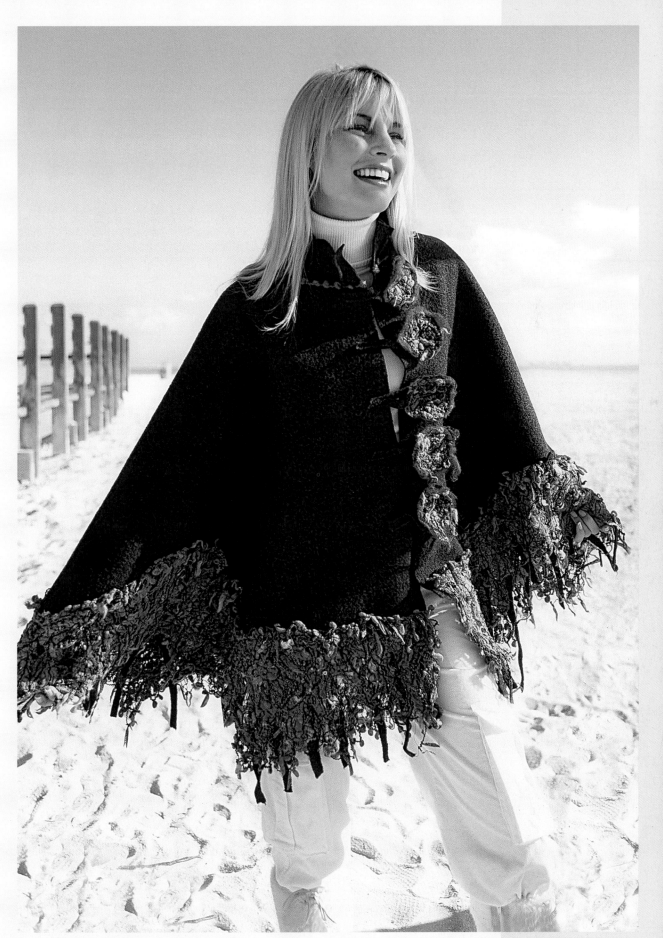

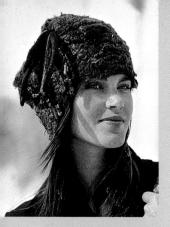

The simple shape is set off by handcrafted strands of felt for a fun look.

Hat
Size
Circumference of head
58–62cm (22¾–24½in)
Level of difficulty
◆◆◆

Belt
Size
115cm (45¼in) long,
15cm (6in) wide
Level of difficulty
◆

Bag
Size
52 × 35cm (20½ × 13¾in)
Level of difficulty
◆◆◆

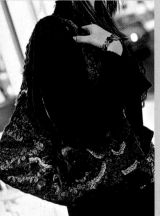

The bright red flower is an eye-catching feature on the bag.

A fiery trio

With these matching accessories in fiery red you can develop your Crazy Felt skills: from a really easy belt to a more challenging bag.

MATERIALS

All designs
- gold brocade trim, 4cm (1½in) wide, 50cm (19¾in)
- spray adhesive, sewing thread in red
- pins, scissors

Hat
- Gedifra yarns: 'Byzanz' (60% polyacrylic, 20% pure new wool, 15% polyamide, 5% met. polyester; length 30m (33yd)/50g): 50g in orange-yellow-brown; 'Sheela' (48% pure new wool, 48% polyacrylic, 4% polyamide; length 30m (33yd)/50g): 50g in red-pink; 'Soft Hair' (40% polyacrylic, 30% mohair, 30% polyamide; length 110m (120yd)/50g): 50g in red
- mohair yarn (with a high mohair content; length between 150m (164yd) and 200m (219yd)/50g): 50g in cherry red
- cotton lace trim in red, 3–4cm (1¼–1½in) wide, 1m (39½in)
- water-soluble stabiliser, 100 × 90cm (39½ × 35½in), e.g. Soluvlies by Freudenberg
- felting wool, 10g each in red, orange and black
- materials for wet felting (see page 8)

Belt
- Gedifra yarns: 'Byzanz' (see hat): 100g red-lilac-beige; 'Sheela' (see hat): 50g red-pink
- mohair yarn (see hat): 100g in red-pink
- fancy special-effect yarn (with fringes, bobbles etc.; length approx. 50m (55yd)/50g): 100g in red
- cotton lace trim in red, 3–4cm wide, 3m (3yd)
- water-soluble stabiliser, 150 × 30cm (59 × 12in), e.g. Soluvlies by Freudenberg
- belt buckle

Bag
- Gedifra yarns: 'Byzanz' (see hat): 50g in red-lilac-beige; 'Sheela' (see hat): 50g in red-pink
- mohair yarn (see hat): 50g in red-pink
- fancy special-effect yarn (see belt): 50g in red
- patchwork fabric in red, approx. 120 × 45cm (47¼ × 17¾in)
- cotton lace trim in red, 3–4cm (1¼–1½in), wide 3m (3yd)
- water-soluble stabiliser, 150 × 60cm (59 × 23½in), e.g. Soluvlies by Freudenberg
- felting wool, 3g each in red, orange and black
- materials for wet felting (see page 8)

INSTRUCTIONS

Hat
Make as for hat on pages 18/19.

Belt
1. Cut out two strips of water-soluble stabiliser measuring 120 × 15cm (47¼ × 6in). Prepare the stabiliser strips as described in foundation course I (pages 6/7). Position two squares of stabiliser decorated with lace trim on each strip (see template, page 41) and stitch in place.
2. Put belt in the washing machine (30°C, 1000rpm), dry and iron flat if necessary.
3. Thread through buckle and stitch down 3cm (1¼in) from buckle.

Bag
1. Cut out 50 squares measuring 4 × 4cm (1½ × 1½in) from the patchwork fabric. For the two outer sections cut out four pieces of water-soluble stabiliser according to the pattern (see page 41).
2. Prepare the two halves of the bag as described in foundation course I (pages 6/7) and stitch, leaving no empty spaces over 2 × 2cm (¾ × ¾in). Make the other half of the bag in the same way. Wash, spin and allow to dry.
3. Copy the pattern for the base of the bag twice (for inner and outer bag) and also for the inner bag on to the patchwork fabric and cut out (pattern on page 41). Place the pieces for the inside of the bag right sides together and stitch, leaving an opening of around 15cm (6in) in a side seam to turn. Stitch the base of the bag to the lower edge of these sections. Do the same with the outer bag.
4. Insert the outer bag into the inner bag with right sides together and join by stitching around the top. Turn right side out through the opening. Stitch up opening.
5. Stitch up the final opening on the shoulder strap using a zigzag stitch (stitch size 6, stitch width 1).
6. To fasten the bag, make a loop from approx. 15cm (6in) of lace trim and sew on to the middle of the bag. Make a felt flower as described in foundation course II (page 9) and sew on to fasten.

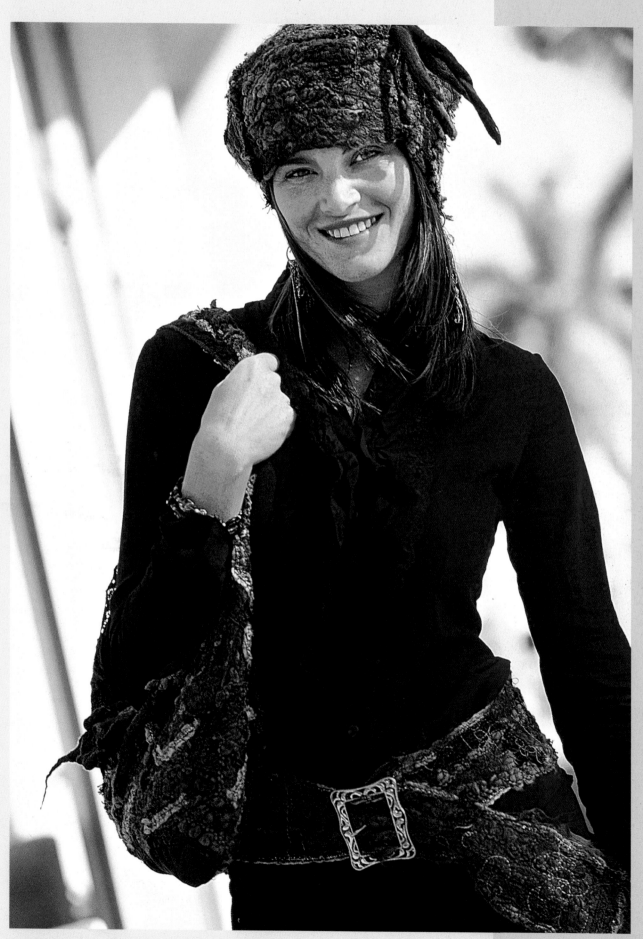

Felt flowers that you have made yourself put the finishing touch to this hat and are particularly effective when contrasting colours are used.

Hat

Size
Circumference of head
56–60cm (22–23½in)

Level of difficulty
◆ ◆

Scarf

Size
100 × 20cm (39½ × 8in)
Level of difficulty
◆

A fresh sea breeze

Looking good whatever the weather – this hat and scarf in magnificent shades of blue almost manage to outshine the sky and sea. With hand-made felt flowers or other jewellery accessories such as brooches or pins you can match the hat to any outfit.

MATERIALS

Both designs
- spray adhesive
- pins, scissors
- sewing thread in blue

Hat
- mohair yarn, e.g. 'Belisana' by Gedifra (70% kid mohair, 15% wool, 5% polyamide; length 115m (126yd)/50g): 100g in royal blue
- tape yarn (polyacrylic with pure new wool; length between 50m (54½yd)and 60m (65½yd)/50g): 50g in blue
- bouclé yarn (mixture of polyacrylic and pure new wool; length approx. 50m (54½yd)/50g): 50g in blue melange
- fancy special-effect yarn (with fringes, bobbles, etc.; length approx. 50m (54½yd)/50g): 50g in blue
- felting wool, 5g each in turquoise, light blue, dark blue and green
- water-soluble stabiliser, 80 × 60cm (31½ × 23½in), e.g. Soluvlies by Freudenberg

Scarf
- mohair yarn (see hat): 10g in royal blue
- glitter yarn, e.g. 'Arista' by Anchor (80% viscose, 20% met. polyester; length 100m (109½yd)/25g): 10g in silver
- felting wool, 20g each in turquoise, light blue and dark blue
- water-soluble stabiliser, 160 × 70cm (63 × 27½in), e.g. Soluvlies by Freudenberg

INSTRUCTIONS

Hat
1. Cut out two circles each 35cm (13¾in) in size according to the pattern (page 42) as well as the side section and insert.
2. For the centre section of the hat apply a very fine layer of spray adhesive to the first circle of stabiliser. Arrange mohair yarn on it, followed by the other yarns and strips of trim approx. 8cm (3in) in length. Spray very lightly with adhesive in between the layers to secure and then also over the completed piece of work. Cover with the second piece of stabiliser and press down.

3. Stitch over this section in circles or criss-cross with the sewing machine until there are no empty spaces over 2 × 2cm (¾ × ¾in). When doing so, make sure that there are no gaps in the yarn-covering between the layers of stabiliser.
4. Prepare the side section and teardrop-shaped insert in the same way.
5. Sew the completed pieces together. Stitch the insert on to one side of the centre section. Pin the side section to the centre section of the hat and make four darts. Try the hat on: it is worn on the side of the head. When doing so, make sure it comes half-way down both ears.
6. Now make two felt flowers and a little ball as in foundation course II (page 9) and sew on to the hat.
7. To produce the Crazy Felt look, put the hat in the washing machine (wool cycle at 30°C), spin (1000rpm) and allow to dry.

Scarf
1. Cut the water-soluble stabiliser into two halves, each measuring 160 × 35cm (63 × 13¾ in).
2. Lay out one section and apply spray adhesive very finely to produce an extremely light bonding surface. Arrange the yarns, starting with the mohair, then the felting wool and lastly the glitter yarns. Spray very lightly with adhesive in between the layers to secure.
3. After the final layer spray finely with adhesive again. Place the second half of the stabiliser on top and press down with the palm of your hand.
4. Stitch criss-cross all over the piece of work with the sewing machine until there are no empty spaces over 3.5 × 3.5cm (1½ × 1½in).
5. For heavy felting wash the scarf at 40°C, spin at 1200rpm and then allow to dry.

TIP

With the hat the seams do not have to be on the inside: they will look very good on the outside too. This effect is enhanced if the darts are also visible on the outside.

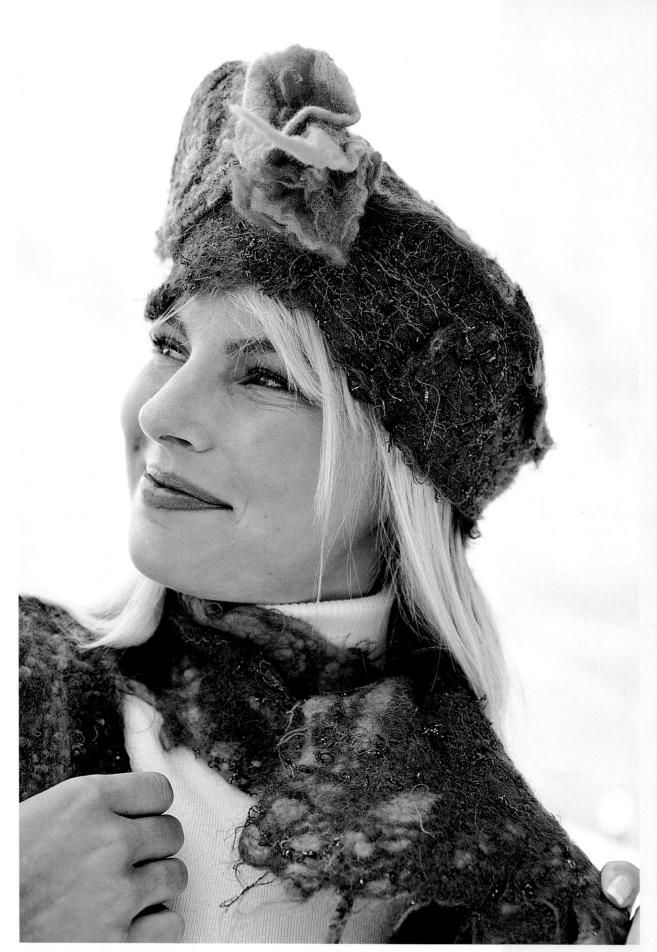

An eye-catching feature: the cool shimmer of silver jewellery against the blue shades of the fluffy yarn.

A matching pair

These two items will be the first things you reach for in your wardrobe! Casual yet elegant, they will jazz up jeans or an elegant evening outfit whatever the season. Very handy: you can leave your handbag at home when wearing this matching set.

Light top
Size
12–14 (US 10–12)
Level of difficulty

Belt bag
Size
16 × 12cm (6¼ × 4¾in)
Level of difficulty

MATERIALS

Both designs
- spray adhesive, sewing thread in turquoise
- pins, scissors

Light top
- 'Fashion Trend Color' (51% pure new wool, 49% polyacrylic; length 90m (98½yd)/50g): 100g in turquoise-green
- mohair yarn (with a high mohair content; length between 80m (87½yd) and 125m (137yd)/50g): 50g in turquoise, 50g in blue
- tape yarn (polyacrylic with pure new wool; length between 50m (54½yd) and 60m (65½yd)/50g): 100g
- bouclé yarn (mixture of polyacrylic and pure new wool; length approx. 50m (54½yd)/50g): 100g in blue melange
- fancy special-effect yarn (with fringes, bobbles, etc.; length approx. 50m (54½yd)/50g): 50g in blue
- water-soluble stabiliser, 200 × 90cm (78¾ × 35½in), e.g. Soluvlies by Freudenberg
- silver brooch, e.g. spiral design

Belt bag
- 'Fashion Trend Color' (see light top): 20g in turquoise-green
- mohair yarn (see light top): 10g in turquoise, 10g in blue
- tape yarn (see light top): 10g in blue
- bouclé yarn (see light top): 20g in blue melange
- fancy special-effect yarn (see light top): 10g in blue
- water-soluble stabiliser, 40 × 80cm (15¾ × 31½in), e.g. Soluvlies by Freudenberg

INSTRUCTIONS

Light top
1. Copy the pattern for the top on page 42 (the measurements given in square brackets) on to the water-soluble stabiliser and cut out twice, one for the front and back. The pattern has been designed with these measurements as shrinkage of between 30 and 40 per cent is to be expected with subsequent heavy felting.
2. Lay out the first section of the stabiliser and apply spray adhesive. Arrange the yarns at random as in foundation course I (page 6), starting with the mohair, followed by the other woollen and special-effect yarns. After the final layer spray finely with adhesive again and cover the piece of work with the second piece of stabiliser and press down lightly. Make the back section in the same way.
3. Stitch criss-cross over both sections with the sewing machine until there are no empty spaces over 2.5 × 2.5cm (1 × 1in).
4. Now arrange strands of different yarns approx. 8cm (3in) in length at the bottom of the top as fringing and stitch in place.
5. Place the front and back right sides together and sew the shoulder seams and the side seams down to 15cm (6in) from the bottom of the garment (at the sides).
6. Finally felt the top by putting in the washing machine at 40°C and 1200rpm.

Belt bag
1. Cut out all the pieces of the bag from water-soluble stabiliser according to the pattern on page 42: two pieces for the front, two for the back with flap, and two for the two fastening strips.
2. Prepare the sections of the bag one after the other as described in foundation course I (pages 6/7): lay out the stabiliser and spray very finely with adhesive. Arrange the yarns, starting with the mohair and then the other yarns, spraying very lightly with adhesive in between the layers to secure. Finally mist over again with the spray adhesive. Cover with the second piece of the stabiliser and stitch at random over the piece of work.
3. Place the sections of the bag right sides together and stitch the side seams. Sew on the fastening strips. Pin the belt loops on to the back and then stitch in place.
4. Felt the bag at 40°C and 1200rpm. After this the bag will have shrunk between 30 and 40 per cent.

NOTE

It is possible to control the felting process more easily when using a tumble dryer. Put the item in the washing machine at 30°C, spin at 1000rpm and place in the dryer wet. Check the size every five minutes.

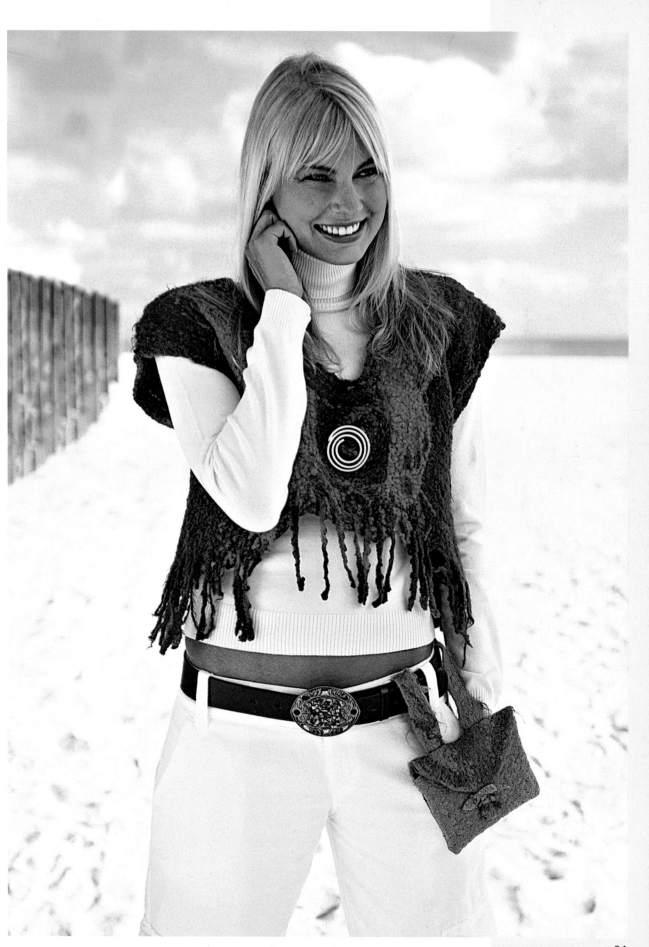

This colourful combination of yarns looks just as good from the front as the back.

Fringed jumper

Size
10–14 (US 8–12)
Level of difficulty
◆◆◆

Stylish fringing

This jumper is bound to become one of your favourite items! The uneven fringing gives it a unique look, and this all-round top is the perfect coordinate whatever the season.

MATERIALS

- 'Serano' by Gedifra (52% polyamide/Tactel, 48% polyamide; length 100m (109½yd)/50g): 50g in green
- 'Tecno Hair Lungo' by Gedifra (100% polyamide; length approx. 80m (87½yd)/50g): 50g in olive-curry
- mohair yarn, e.g. 'Belisana' by Gedifra (70% kid mohair, 15% wool, 15% polyamide; length 115m (126yd)/50g): 150g in olive
- microfibre yarn (fluffy yarn), e.g. 'Tecno Hair Lungo' by Gedifra (100% polyamide; length approx. 80m (87½yd)/50g): 100g in olive, 50g in petrol
- glitter-effect yarn (length between 30m (33yd) and 50m (54½yd)/50g): 50g in blue
- water-soluble stabiliser, 280 × 90cm (110½ × 35½in), e.g. Soluvlies by Freudenberg
- spray adhesive
- sewing thread in shades of green
- pins
- scissors

INSTRUCTIONS

1. First of all cut out the water-soluble stabiliser for the sections of the jumper according to the pattern on page 42 as follows: front and back twice, sleeves four times.
2. Now prepare the individual jumper sections one after the other.
As shown in foundation course I (page 6), lay out one section of stabiliser and apply spray adhesive very finely to produce an extremely light bonding surface. Arrange the yarns at random, starting with the mohair, followed by the other special-effect yarns, based either on your own ideas or on the photo opposite. For the fringing on the appropriate edges of the front, back and sleeves, allow some long olive-coloured threads to extend beyond the edge of the stabiliser. Spray very lightly with adhesive in between the layers to secure. Mist over with adhesive and put the covering piece on top.
3. Now stitch over the sections of the jumper with the sewing machine in circles or criss-cross at random until there are no empty spaces over 2 × 2cm (¾ × ¾in). Only sew up to the edge of the stabiliser, leaving out the fringing.

4. Once all sections have been completed, place the front and back right sides together and stitch the shoulder seams.
5. Pin the sleeves over the shoulder seams to the middle of the sleeve and then stitch.
6. The last seams are the side seams, which are sewn with a continuous seam running up the side and along the underside of the sleeve.
7. To give the jumper the Crazy Felt look, put it in the washing machine on a wool cycle at 30°C, spin at 1000rpm and then allow to dry.

TIP

This casual-style jumper can also be made by arranging the yarns more neatly side by side and then sewing in straight lines. It will look particularly original if you also crochet around the edges with simple basic stitches.

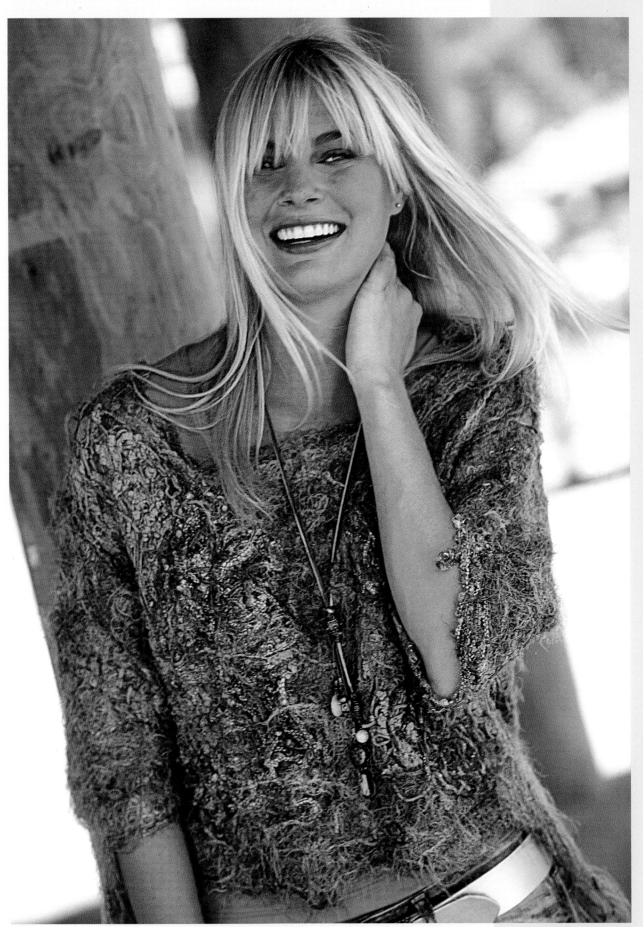

A striking effect: the red felt flower looks great with a patterned background in black

Wrap
Size
approx. 130 × 40cm
(51 × 15¾in)
Level of difficulty
◆

Arm warmers
Size
approx. 30cm (12in) diameter
long, 10–15cm (4–6in)
Level of difficulty
◆

Evening bag
Size
approx. 22 × 20cm (8¾ × 8in)
Level of difficulty
◆◆◆

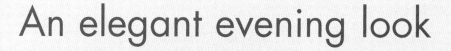

An elegant evening look

This patterned three-piece set in black will not only keep you warm on cool evenings but is bound to make you the centre of attention.

MATERIALS

All designs
- Gedifra yarns: 'Soft Hair' (40% polyacrylic, 30% mohair, 30% polyamide; length 110m (120yd)/50g): 100g in grey, 50g in black; 'Sheela' (48% pure new wool, 48% polyacrylic, 4% polyamide; length 30m (33yd)/50g): 100g in black
- spray adhesive
- sewing thread in black
- pins, scissors

Wrap
- blouse fabrics patterned in black, total size 30 × 60cm (12 × 23½in)
- cotton lace trim in black, 3–4cm (1¼–1½in) wide, 1m (2yd)
- water-soluble stabiliser, 150 × 90cm (59 × 35½in), e.g. Soluvlies by Freudenberg

Arm warmers
- blouse fabrics patterned in black, total size 10 × 60cm (4 × 23½in)
- cotton lace trim in black, 3–4cm (1¼–1½in) wide, 60cm (23½in)
- water-soluble stabiliser, 90 × 90cm (35½ × 35½ in), e.g. Soluvlies by Freudenberg

Evening bag
- blouse fabrics patterned in black, total size 10 × 60cm (4 × 23½in)
- patchwork fabric patterned in black, 45 × 30cm (17¾ × 12in)
- cotton lace trim in black, 3–4cm (1¼–1½in) wide, 60cm (23½in)
- water-soluble stabiliser, 90 × 90cm (35½ × 35½ in), e.g. Soluvlies by Freudenberg
- 1 pair of bag handles in black
- felting wool, 5g each in red, orange, black and green
- materials for wet felting (see page 8)

You should expect to use about half of the yarn for the stole, and the remaining material will then be sufficient for the arm warmers and evening bag: 10 to 20g each.

INSTRUCTIONS

Wrap
1. Lay out the water-soluble stabiliser lengthwise and fold over into equal halves, cutting through with the scissors. Cut the blouse fabrics into squares measuring 4 × 4cm (1½ × 1½in) and the lace trim into lengths of 5cm (2in).

2. Lay out one section of the stabiliser (45 × 150cm (17¾ × 59in)) and apply spray adhesive very finely. Arrange the yarns as shown in the foundation course I (pages 6/7), starting with the mohair and then adding other yarns, squares of fabric and lace. Spray very lightly with adhesive in between the layers to secure and mist over again. Place the second layer of stabiliser on top and press down.

3. Fix the piece of work in place with pins at the corners and stitch over it criss-cross with the sewing machine until there are no empty spaces over 2.5 × 2.5cm (1 × 1in).

4. Now put the stole in the washing machine on a 30°C wool cycle and spin at 1000rpm.

Arm warmers
1. Cut out four pieces of water-soluble stabiliser according to the pattern on page 43 (two each for the front and back). Then cut the blouse fabrics into squares measuring 4 × 4cm (1½ × 1½in) and the lace trim into lengths of 5cm (2in).

2. The two arm warmers are made up at the same time to ensure they turn out the same. Lay out a piece of stabiliser for each arm warmer and arrange the yarns according to foundation course I (pages 6/7), starting with the mohair followed by the other yarns, squares of fabric and lace. Spray very lightly with adhesive in between the layers to secure. Mist over again, place the second layer of stabiliser on top and press down. Prepare the back sections of the arm warmers in the same way (once again as a pair).

3. Now stitch over the four sections of the arm warmers at random. Place the two halves of each arm warmer right sides together and stitch the side seams to close. Turn right side out and wash.

Evening bag
1. Copy the pattern (page 43) for the bag on to the water-soluble stabiliser and patchwork fabric and cut out.

2. Prepare the outer bag as in foundation course I (pages 6/7). Place the strips for the bag handles right sides together and stitch. Turn right side out.

3. Place the inner and outer bag right sides together and stitch the side seams, leaving an opening of approx. 10cm (4in) in the inner bag. Turn right side out and stitch up opening.

4. Insert the bag handles through the strips and firmly stitch the strips to the inside of the bag.

5. Felt the flower and leaf (see foundation course II, page 9) and sew on to the bag (see photograph).

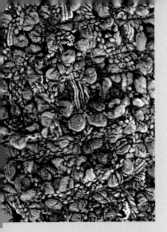

Tape and bouclé yarn intertwined – this unusual combination looks just great!

Poncho in shades of blue

Size
10–14 (US 8–12)
Level of difficulty

◆

Ideal for outside

This poncho is both practical and smart! It is the very thing to wear when a jacket is too hot but a jumper by itself is not warm enough. It takes next to no time to make and is a perfect introduction for beginners.

MATERIALS

- bouclé yarn (mixture of polyacrylic and pure new wool; length approx. 50m (54½yd)/50g): 150g in blue
- tape yarn length approx. 80m (87½yd)/50g: 100g in blue-lilac
- water-soluble stabiliser, 150 × 90cm (59 × 35½in), e.g. Soluvlies by Freudenberg
- sewing thread in lilac
- spray adhesive
- pins
- scissors

INSTRUCTIONS

1. Cut out four pieces of water-soluble stabiliser according to the pattern for the poncho (page 43) (two for the front and two for the back).
2. Lay out one piece of the stabiliser as shown in foundation course I (page 6) and apply a very thin layer of spray adhesive to create an extremely light bonding surface. Arrange the yarns at random, starting with the denim tape, followed by the bouclé, spraying very lightly with adhesive in between the layers to secure. Allow several long strands of bouclé yarn to extend beyond the stabiliser in the middle (see the photograph on the right). Mist over with the adhesive again and put the covering piece on top. Prepare the back section in the same way but omitting the fringing.
3. Now stitch over the sections of the cape with the sewing machine in circles or criss-cross at random until there are no empty spaces over 2 × 2cm (¾ × ¾in). Only sew to the edge of the stabiliser, leaving out the fringing.
4. Place the pieces right sides together and lockstitch the shoulder seams.
5. Finally put the poncho in the washing machine on a 30°C wool cycle and spin (1000rpm).

NOTE

This Crazy Felt poncho has been made without felting. The felt look is produced by combining pure new wool and tape yarn, with the felt effect being enhanced by the structure and mixture of different colours.

TIP

Decorative eye-catching features – there is plenty of scope for all your ideas with this poncho. The design shown here has been kept very simple to ensure that beginners can cope with arranging the yarns. You can also use other designs, for example combining the side-by-side method (see foundation course II, page 8) with yarns arranged at random or including trim and lace.

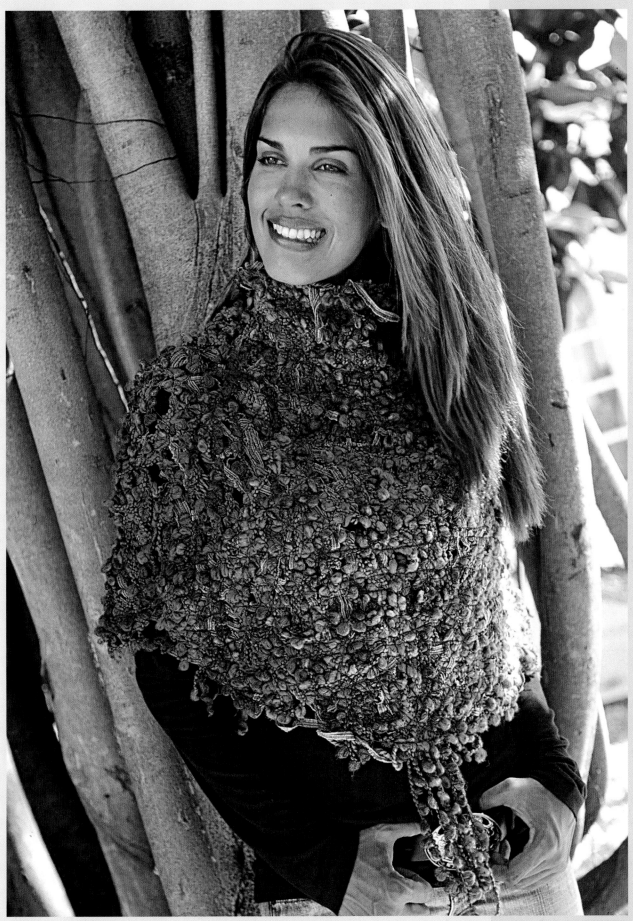

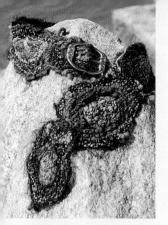

The narrow belt is made up of overlapping circles of Crazy Felt.

Luxurious stretch belt

Size

160 × 40cm (63 × 15¾in) (centre section 80cm (31½in) wide, 40cm (15¾in) deep)

Level of difficulty

◆ ◆

Narrow belt

Size

120cm (47¼in) long, 12–15cm (4¾–6in) wide

Level of difficulty

◆

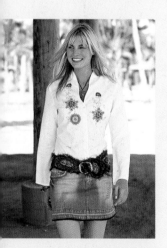

This eye-catching item looks great with a denim mini-skirt.

Baroque accessories

These accessories will not just look striking with cowboy boots and blouses – they will also be the centre of attention when worn over the shoulder with a simple jumper or a long shirt.

MATERIALS

Both designs
- spray adhesive
- sewing thread in black
- pins, scissors

Luxurious stretch belt (photo on right)
- Gedifra yarns: 'Scarlet' (65% polyacrylic, 35% pure new wool; length approx. 50m (54½yd)/50g): 50g in orange-curry; 'Serano' (52% polyamide/Tactel, 48% polyamide; length 100m (109½yd)/50g): 50g in brown, 50g in blue
- mohair yarn (with a high mohair content; length between 80m (87½yd) and 125m (136½yd)/50g): 50g in turquoise
- fancy special-effect yarn (with fringes, bobbles, etc.; length approx. 50m (54½yd)/50g): 100g in blue-black
- water-soluble stabiliser, 150 × 90cm (59 × 35½in), e.g. Soluvlies by Freudenberg
- gold braid, approx. 3cm (1¼in) wide, 2m (2yd)
- cotton lace trim, approx. 2.5cm (1in) wide, 1m (1yd)
- black elastic, 3cm (1¼in) wide, 1m (1yd)
- clear elastic, 3cm (1¼in) wide, 1m (1yd)
- glass beads in blue, green, lilac and golden yellow, diameter 4–8mm (⅛–¼in)
- silver belt buckle, 8cm (3in)

Narrow belt (left)
- Gedifra yarns:'Byzanz' (60% polyacrylic, 20% pure new wool, 15% polyamide, 5% met. polyester; length 30m (33yd)/50g): 20g in orange-yellow-brown; 'Sheela' (48% pure new wool, 48% polyacrylic, 4% polyamide; length 30m (33yd)/50g): 20g in red-orange; 'Soft Hair' (40% polyacrylic, 30% mohair, 30% polyamide; length 110m (120yd)/50g): 20g in red
- water-soluble stabiliser, 80 × 90cm (31½ × 35½), e.g. Soluvlies by Freudenberg
- cotton lace trim, approx. 2.5cm (1in) wide, 2m (2yd)
- silver belt buckle

INSTRUCTIONS

Luxurious stretch belt

1. For the centre section of the belt cut out two pieces of water-soluble stabiliser to size according to the pattern (page 43). For the narrow connecting side sections cut out six squares from the stabiliser measuring 20 × 20cm (8 × 8in).

2. Apply a very thin layer of spray adhesive to a square of stabiliser and arrange the yarns in a circular pattern. To do so, make an inner ring out of one yarn and then position rings around it using the other yarns. Spray thinly with adhesive again and cover with the second piece of stabiliser. Make three circles.

3. Stitch over each piece in circles or criss-cross until there are no empty spaces over 2 × 2cm (¾ × ¾in).

4. Also prepare the centre section of the belt (80 × 40cm (31½ × 15¾in)). You can make circular patterns if you wish but bear in mind that such designs will not be recognisable as such after the material has been gathered, i.e. after attaching the elastic.

5. Now stitch three circles to each side of the belt. When doing so, make sure that the circles just overlap each other. Turn the belt over and sew on the pieces of elastic over the wide centre area, 5cm (2in) from the edge. Now try on the belt – the size can easily be adjusted with the help of pins.

6. To create the Crazy Felt look put the belt in the washing machine (wool cycle at 30°C) and spin (1000rpm). Allow to dry.

7. Insert the right-hand end of the belt in the buckle. Fold over the end of the belt approx. 2cm (¾in) and stitch down with the sewing machine using a zigzag stitch (stitch size 6, stitch width 1). Make a few strings of beads and sew them on to the belt (see photograph).

Narrow belt

1. Cut out 18 squares of stabiliser measuring 20 × 20cm (8 × 8in). The number of circles (squares of stabiliser) required will depend on the size of your waist or hips.

2. Make nine circles as described for the stretch belt (see step 2). Now stitch over each piece in circles or criss-cross with the sewing machine until there are no empty spaces over 2 × 2cm (¾ × ¾in).

3. Stitch the circles together, making sure that they overlap each other slightly on the belt. Put the belt in the washing machine (wool cycle at 30°C), spin at 1000rpm and allow to dry.

4. Sew on the buckle.

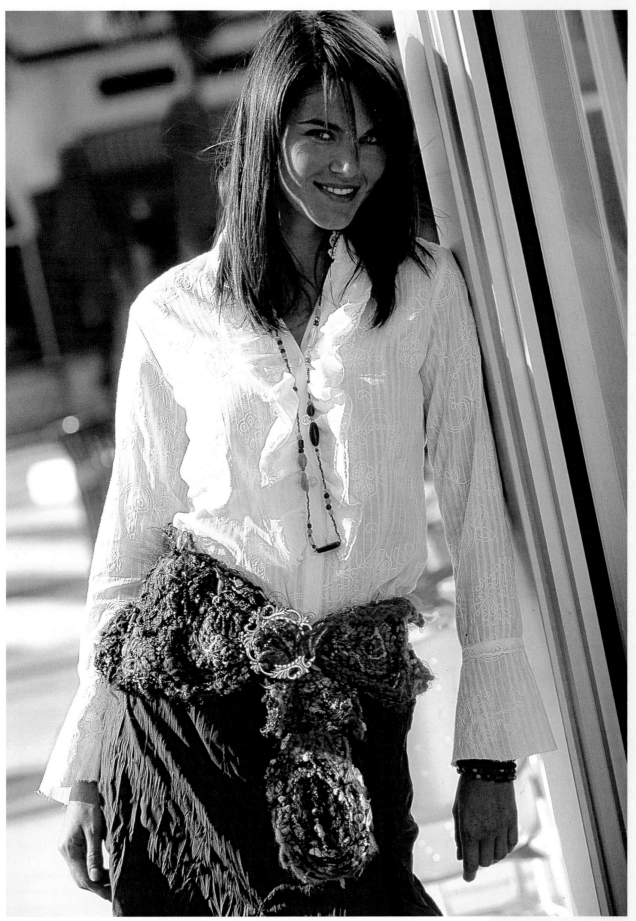

The hand-made felt flower turns the bag into a real designer item.

Fluffy jumper
Size
12–16 (US 10–14)
Level of difficulty

◆◆

Felt bag in blue
Size
30 × 45cm (12 × 17¾in)
Level of difficulty

◆◆

Feel-good creations

This jumper will always attract attention thanks to the beautiful shades of yarn – blue, green, lilac and pastel. The felted bag is also a real eye-catcher – use a tumble dryer for heavy felting to greatly reduce the work time required.

MATERIALS

Both designs
• sewing thread in blue, pins, scissors

Fluffy jumper
• Gedifra yarns: 'Scarlet' (65% polyacrylic, 35% pure new wool; length approx. 50m (54½yd)/50g): 100g in green; 'Serano' (52% polyamide/Tactel, 48% polyamide; length approx. 100m/50g): 50g in royal blue; 'Tecno Hair Lungo' (100% polyamide; length approx. 80m (87½yd)/50g): 50g in turquoise-blue
• mohair yarn, e.g. 'Belisana' by Gedifra (70% kid mohair, 15% wool, 15% polyamide; length 115m (126yd)/50g): 150g in blue
• tape yarn (polyacrylic with pure new wool; length between 50m (54½yd) and 60m (65½yd)/50g): 50g in green-red
• water-soluble stabiliser, 200 × 90cm (78¾ × 35½in), e.g. Soluvlies by Freudenberg
• spray adhesive, sewing thread in lilac
• crochet hook size 6 (US size K)

Felt bag
• patchwork fabric patterned in blue, 60 × 120cm (23½ × 47¼in)
• 1 pair of bamboo bag handles
• felting wool, 25g each in turquoise and royal blue, 10g each in green and light blue
• materials for wet felting (see page 8)

INSTRUCTIONS

Fluffy jumper
1. Copy the pattern for the jumper (page 44) on to the water-soluble stabiliser four times and cut out.
2. For the front lay out a piece of stabiliser and apply a very thin layer of spray adhesive. The different yarns are then positioned side by side (see foundation course II, page 8) over the entire area, spaced at 1cm (½in) from each other. Start with the mohair yarn and then arrange the next yarn side by side in the gaps between the strands of mohair. Continue until the entire piece of stabiliser is covered. Do not cover with the second piece of stabiliser but leave open and prepare the back section in the same way.

3. Finally apply a very thin layer of spray adhesive to both sections and cover each with a second piece of stabiliser.
4. Pin the item together at the corners and outer edges. Stitch over the yarns first crosswise and then lengthwise, with the rows of stitching between 3 and 4cm (1¼ and 1½in) apart.
5. Put the two sections of the jumper right sides together and lockstitch the shoulder and side seams.
6. For the felted look, put the jumper in the washing machine on a wool cycle at 30°C, spinning at 1000rpm and allow to dry.
7. For the fringes cut pieces of the tape yarn approx. 15cm (6in) long and use the crochet hook to attach them to the bottom of the garment.

Felt bag in blue
1. Prepare a felt bag (see foundation course II, page 8), laying the felting wool in three layers (crosswise) over an area of 60 × 50cm (23½ × 19¾in) and felt lightly.
2. Once the wool has become firmer, roll in a towel. Tie the ends of the roll and put in a tumble dryer for 20 minutes to felt.
3. To make the inner bag, cut out two pieces of the patchwork fabric, and for the outer bag two pieces of the felted material according to the pattern (page 44).
4. For the inner bag place the section right sides together and stitch the side seams, leaving an opening of around 15cm (6in) in a side seam to turn. Take the outer bag and place the sections right sides together. Stitch to the top and then turn right side out.
5. To attach the handles, cut four strips of patchwork fabric measuring 15 × 3cm (6 × 1¼in), and with right sides together, stitch with a seam allowance of 0.5cm (¼in). Pin these strips to the points marked on the pattern.
6. Place the outer bag inside the inner bag with right sides together and stitch round the top to close. Turn through the opening and stitch up. Attach the bamboo handles with the strips of patchwork.
7. Felt a flower (foundation course II, page 9) and sew on by hand.

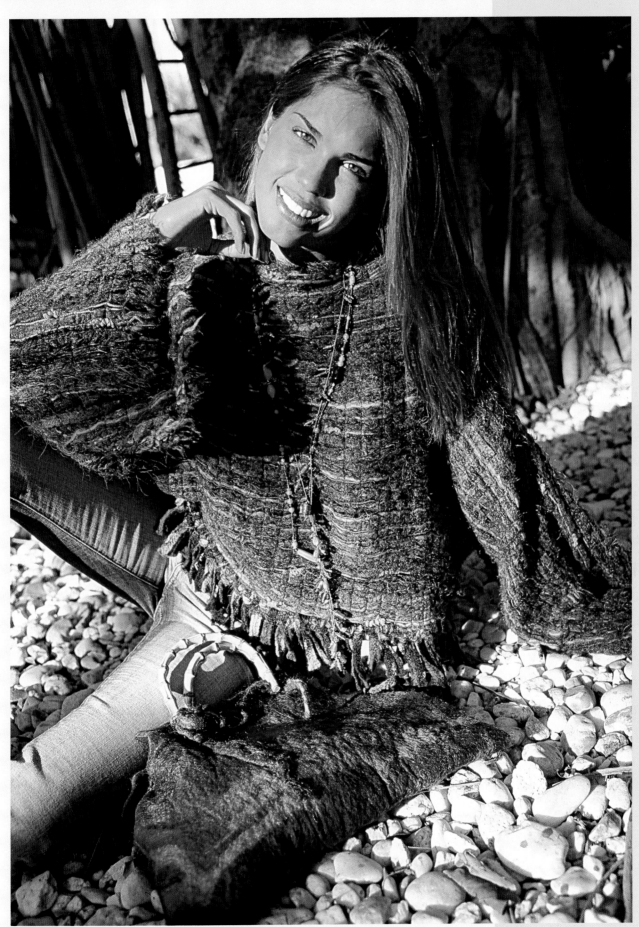

Have you got your heart in the right place? Why not wear it on your sleeve? Your right shoulder is perfect!

Light top

Size
12–18 (US 10–16)
Level of difficulty
◆

Felt bag in brown

Size
30 × 40cm (12 × 15¾in)
Level of difficulty
◆◆

A smart yet practical item for everyday use.

Casual yet stylish

This top is ideal for anyone who prefers a lighter, more casual look. Using microfibre yarn makes this garment very lightweight yet it looks as if it has been felted. The brown bag is made using the classic felting technique.

MATERIALS

Both designs
- sewing thread in brown
- pins, scissors
- materials for wet felting (see page 8)

Light top
- 'Scarlet' by Gedifra (65% polyacrylic, 35% pure new wool; length approx. 50m (54½yd)/50g): 50g in brown
- 'Tecno Hair Lungo' by Gedifra (100% polyamide; length approx. 80m (87½yd) /50g): 50g in brown-black
- mixed yarn containing wool and glitter, e.g. 'Byzanz' by Gedifra (60% polyacrylic, 20% pure new wool, 15% polyamide, 5% met. polyester; length 30m (33yd)/50g): 100g in brown-grey
- microfibre yarn (fluffy yarn), e.g. 'Tecno Hair Lungo' by Gedifra (100% polyamide; length approx. 80m (87½yd)/50g): 50g in brown
- fancy special-effect yarn (with fringes, bobbles, etc.; length approx. 50m (54½yd)/50g): 50g in black-brown
- water-soluble stabiliser, 150 × 90cm (59 × 35½in), e.g. Soluvlies by Freudenberg
- spray adhesive
- sewing thread in black
- felting wool, 10g each in dark brown, light brown, beige and black

Felt bag in brown
- patchwork fabric patterned brown, 60 × 120cm (23½ × 47¼in)
- 1 pair of bamboo bag handles
- fine merino wool, 10g each in light brown, dark brown and grey
- felting wool, 25g each in brown, light brown and grey
- felting needle

INSTRUCTIONS

Light top
1. Copy the pattern for the top (page 42) on to the water-soluble stabiliser using the measurements given in square brackets and cut out twice each for the front and back.

2. Lay out the first piece of stabiliser and apply a very thin layer of spray adhesive to create a light bonding surface. Arrange the yarns at random as shown in foundation course I (page 6), starting with the mohair, followed by the other wool and special-effect yarns.

3. After the final layer, spray your piece of work very finely with adhesive, cover with the second piece of stabiliser and press down lightly.

4. Prepare the back section in the same way.

5. Stitch over both pieces with the sewing machine in a criss-cross pattern, sewing closely until there are no empty spaces over 2.5 × 2.5cm (1 × 1in).

6. Cut lengths of different yarns into pieces measuring approx. 8cm (3in) and sew to the bottom of the top.

7. Place the two sections of the top right sides together and stitch the shoulder and side seams, down to 15cm (6in) above the bottom of the garment (at the sides).

8. Felt the top by putting in the washing machine on a 30°C wool cycle and a maximum of 1000rpm.

9. Felt a heart-shaped leaf and little ball and sew on by hand.

Felt bag in brown
1. First felt the material as for the blue bag (see also foundation course II, page 8) and cut out the finished felted material and the patchwork fabric (see page 30, steps 1 to 3).

2. To decorate the bag, felt four leaves measuring approx. 10 × 8cm (4 × 3in) in the shape of a heart. Use the felting needle to add texture to the surface by repeatedly inserting it in both pieces. Roll in a towel and put in a tumble dryer for ten minutes.

3. Stitch together the bag sections and strips as for the blue bag and turn. Stitch the last seam to close and attach the handles (see page 30, steps 5 and 6).

4. If desired, make little felt balls and leaves in the shape of a heart. Arrange on both sides of the bag and sew on by hand.

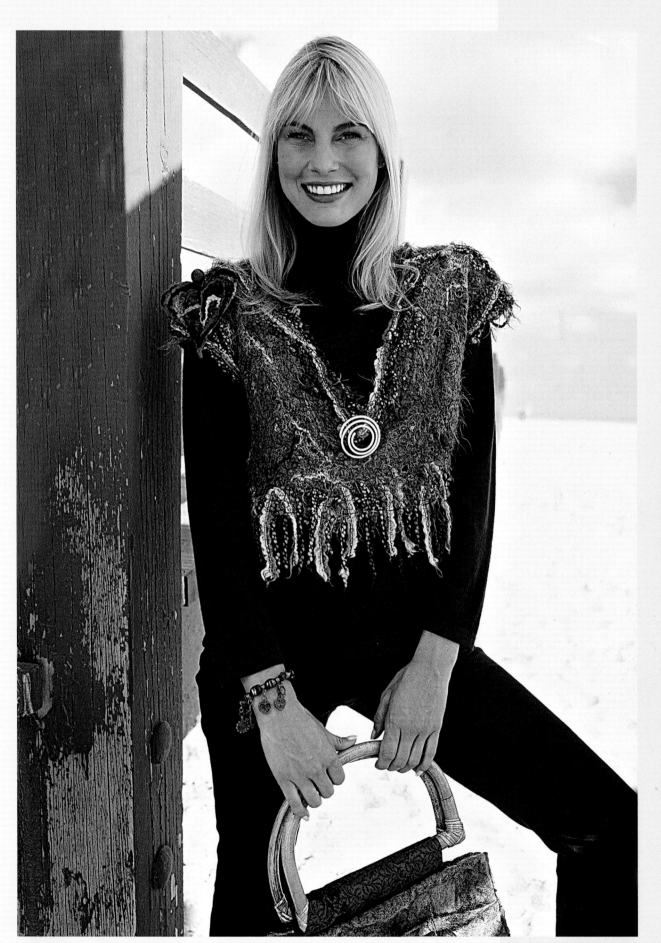

There's no problem here with tying knots or wrapping this scarf around you – simply insert one end through the opening.

Poncho
Size
12–18 (US 10–16)
Level of difficulty
◆

Hat
Size
Circumference of head
56–60cm (22–23½in)
Level of difficulty
◆ ◆

Scarf
Size
approx. 150 × 25cm
(59 × 10in)
(without fringes)
Level of difficulty
◆

Inca-style fashion

This versatile poncho is super-light and very quick to make. The use of mohair and woollen yarns means that it is lovely and warm to wear but is still breathable. The fashionable Inca-style outfit is rounded off by a matching hat.

MATERIALS

All designs
- spray adhesive, sewing thread in brown and black
- pins, scissors

Poncho
- Gedifra yarns: 'Byzanz' (60% polyacrylic, 20% pure new wool, 15% polyamide, 5% met. polyester; length 30m (33yd)/50g): 50g in orange-yellow-brown; 'Tecno Hair Lungo' (100% polyamide; length approx. 80m (87½yd)/50g): 100g in brown
- mohair yarn, e.g. 'Belisana' by Gedifra (70% kid mohair, 15% wool, 15% polyamide; length 115m (126yd)/50g): 150g in grey
- tweed-effect yarn (mixture of pure new wool and polyacrylic; length approx. 50m (54½yd)/50g): 50g in anthracite-copper melange
- fancy special-effect yarn (with fringes, bobbles, etc.; length approx. 50m (54½yd)/50g): 100g in brown, 100g in anthracite
- water-soluble stabiliser, 600 × 90cm (236 × 35½in), e.g. Soluvlies by Freudenberg

Hat
- Gedifra yarns: 'Byzanz' (see poncho): 10g in orange-yellow-brown; 'Tecno Hair Lungo' (see poncho): 20g in brown
- mohair yarn (see poncho): 30g in grey
- tweed-effect yarn (see poncho): 15g in anthracite-copper melange
- fancy special-effect yarn (see poncho): 20g in brown, 20g in anthracite
- water-soluble stabiliser, 100 × 90cm (39½ × 35½in), e.g. Soluvlies by Freudenberg
- felting wool, 10g each in brown, black, beige and light brown
- materials for wet felting (see page 8)

Scarf
- Gedifra yarns: 'Byzanz' (see poncho): 50g in orange-yellow-brown; 'Tecno Hair Lungo' (see poncho): 20g in brown
- mohair yarn (see poncho): 30g in grey
- tweed-effect yarn (see poncho): 15g in anthracite-copper melange
- fancy special-effect yarn (see poncho): 50g in brown, 20g in anthracite
- water-soluble stabiliser, 160 × 50cm (63 × 19¾in), e.g. Soluvlies by Freudenberg

INSTRUCTIONS

Poncho
1. Copy a rectangle measuring 150 × 55cm (59 × 21¾in) on to the water-soluble stabiliser four times and cut out.
2. Arrange the yarns on the pieces of stabiliser according to foundation course I (pages 6/7). Add fringing (8cm (3in)) to one of the long sides and stitch over the piece of work at random. Sew the front and back sections together on the long side without fringing, leaving an opening of 25cm (10in) free for the neck.
3. Put in the washing machine on a wool cycle at 30°C, spinning at 1000rpm.

Hat
1. This hat is basically made up in the same way as the hat on pages 18/19. Cut out water-soluble stabiliser for the sections of the hat twice, according to the pattern (page 42).
2. Arrange the yarns on all hat sections according to foundation course I (pages 6/7) and stitch.
3. Join the completed pieces together. Stitch the insert on to one side of the centre section. Pin the side section to the centre section of the hat and make about four darts. The hat will sit best if you use a seam allowance of 1cm (½in). Try the hat on: it is worn on the side of the head. When doing so, make sure it comes half-way down both ears.
4. To produce the felted look, put the hat in the washing machine (wool cycle at 30°C), spin (1000rpm) and allow to dry.
5. Now make a few felt flowers (see foundation course II, page 9) and sew on to the hat by hand.

Scarf
1. Cut out the water-soluble stabiliser twice according to the pattern on page 44.
2. Lay out the first section of stabiliser and mist over with spray adhesive. Arrange the yarns at random as in foundation course I (pages 6/7), leaving a square opening measuring approx. 20 × 20cm (8 × 8in) at one end. Cover with the second piece of stabiliser.
3. Stitch over the piece in circles or criss-cross with the sewing machine leaving no empty spaces over 2 × 2cm (¾ × ¾in).
4. Put in the washing machine (30°C and 1000rpm) and allow to dry.

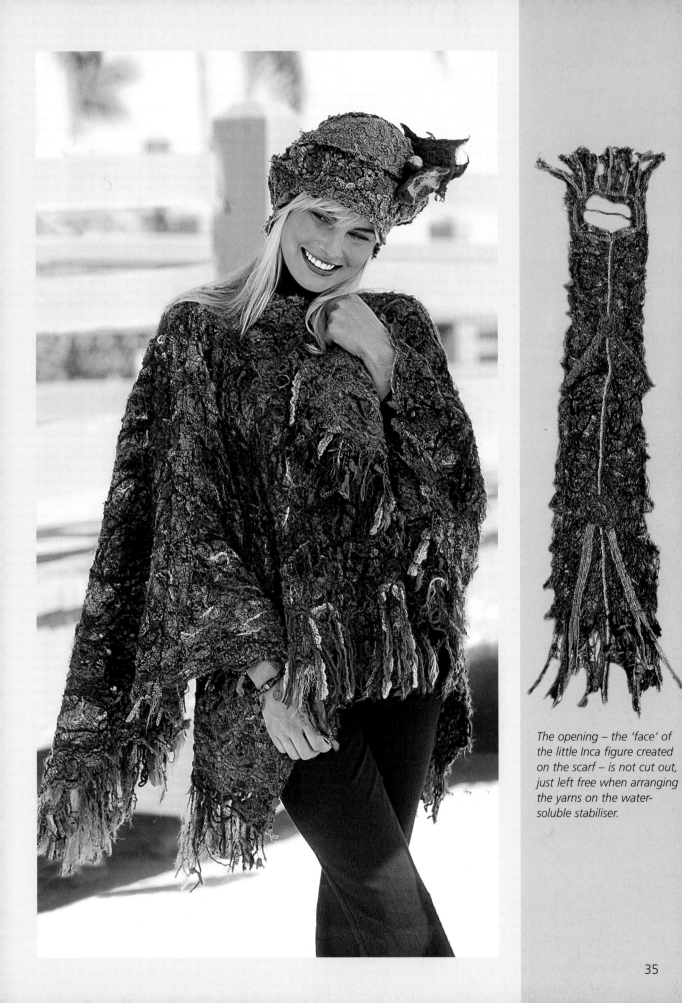

The opening – the 'face' of the little Inca figure created on the scarf – is not cut out, just left free when arranging the yarns on the water-soluble stabiliser.

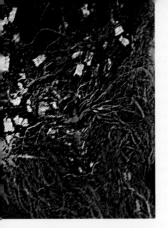

Peacock feathers give this poncho an exotic look, but other feathers can be used as well.

Poncho

Size
10–14 (US 8–12)
Level of difficulty

◆

Fashion with feathers

Peacock feathers are an eye-catching feature on any garment. You can find a whole range of feathers suitable for Crazy Felt at your local craft shop. This poncho is so light, not even 150g (6oz), that you will hardly notice you are wearing it. The quantity of wool stated is enough for two garments.

MATERIALS

- 'Tecno Hair Lungo' by Gedifra (100% polyamide; length approx. 80m (87½yd)/50g): 100g in brown
- mohair yarn, e.g. 'Belisana' by Gedifra (70% kid mohair, 15% wool, 15% polyamide; length 115m (126yd)/50g): 100g in grey
- fancy special-effect yarn (with fringes, bobbles, etc.; length approx. 50m (54½yd)/50g): 50g in brown, 50g in grey
- water-soluble stabiliser, 150 × 90cm (59 × 35½in), e.g. Soluvlies by Freudenberg
- 3 peacock feathers
- spray adhesive
- sewing thread in brown and black
- pins
- scissors

INSTRUCTIONS

1. Cut out the pattern for the poncho (page 43) from water-soluble stabiliser four times to size (two for the front, two for the back).
2. Trim the peacock feathers to approx. 15cm (6in) in length.
3. Lay out the first piece of stabiliser for the front and apply a very thin layer of spray adhesive to create an extremely light bonding surface. Arrange the yarns at random, starting with the mohair. When adding further layers of yarn, spray very lightly with adhesive in between the layers to secure. Once the piece of stabiliser has been covered all over with yarn, position two peacock feathers in the middle (at neck level). Spray the entire piece of work very finely with adhesive and lay the second piece of stabiliser on top. Prepare the back section in the same way, also placing a peacock feather in the middle, but at the bottom.
4. If you like fringing, you can let strands of yarn approx. 12–15cm (4¾–6in) in length extend beyond the stabiliser at the bottom on the front and back.

5. Stitch over the sections with the sewing machine in circles or criss-cross at random until there are no empty spaces over 2 × 2cm (¾ × ¾in).
6. Put the two sections right sides together and stitch from the neckline, over the shoulder to the end points at the side.
7. Put the poncho in the washing machine on a wool cycle at 30°C and spin at 1000rpm.

TIP

When you remove the head of the peacock feather, you can cut off the fine, lustrous feathers running down the quill and use them to decorate the stabiliser. If you then stitch over the piece of work with close and random stitching, 90 per cent of these little feathers will remain caught in the stitching, creating interesting effects depending on the light.
The use of feathers does not prevent this item from being washed. However, you should not exceed 30°C or the feathers will become porous.

A wonderful shawl that is warm yet light – just the thing for cool summer evenings.

Bolero

Size
14–18 (US 12–16)
Level of difficulty

◆◆◆

Shawl

Size
approx. 180 × 25cm
(71 × 10in)
Level of difficulty

◆

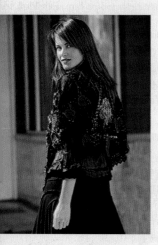

The back of this bolero is also delightful.

Viva España

With this lively duo in red and black you can give full rein to your artistic inclinations. The combination of microfibre yarns, mohair and felting wool is so versatile that you can create many new effects.

MATERIALS

Both designs
- spray adhesive, sewing thread in black
- pins, scissors
Bolero
- 'Brazilia Lungo' by Schachenmayr (100% polyester; length approx. 60m (65½yd)/50g): 100g in black
- 'Tecno Hair Lungo' by Gedifra (100% polyamide; length approx. 80m/50g): 100g in black
- mohair yarn, e.g. 'Belisana' by Gedifra (70% kid mohair, 15% wool, 15% polyamide; length 115m (126yd)/50g): 150g in black
- glitter-effect yarn, (length between 30m (33yd) and 50m (54½yd)/50g): 50g in red
- felting wool, 290g in red
- water-soluble stabiliser, 150 × 90cm (59 × 35½in), e.g. Soluvlies by Freudenberg
Shawl
- 'Brazilia Lungo' by Schachenmayr (see bolero): 20g in black
- 'Tecno Hair Lungo' by Gedifra (see bolero): 50g in black
- mohair yarn (see bolero): 100g in black
- glitter-effect yarn (see bolero): 50g in red
- water-soluble stabiliser, 190 × 60cm (74¾ × 23½in)

INSTRUCTIONS

Bolero
1. Copy the parts for the bolero on to the water-soluble stabiliser twice according to the pattern on page 44 and cut out.
2. Arrange yarns on all sections of the bolero according to foundation course I (pages 6/7) and stitch, making sure that the fronts are laid out symmetrically. If you wish, you can use different designs for the front sections, e.g. one with a checked pattern and the other with stripes and circles made of felting wool. The triangular pieces (see pattern) should be made up in different colours so they are shown off to better advantage when knotted later on.

3. Sew the completed parts together. To do so, place the fronts on the back section right sides together and close the shoulder seams; ensure you make the neckline large enough, at least 25cm (10in) in the middle. Take each triangle and place on the front section right sides together and stitch in place. Finally stitch the side seams.
4. For the Crazy Felt look put in the machine, wash on a wool cycle at 30°C and spin (1000rpm).

Shawl
1. Divide the water-soluble stabiliser in half lengthwise – two pieces, 190 × 30cm (74¾ × 11¾in).
2. Apply spray adhesive to one section of the stabiliser according to foundation course I (pages 6/7) and arrange the yarns at random, starting with the mohair. Spray very lightly with adhesive in between the layers to secure. Mist over again with spray adhesive and put the second layer of stabiliser on top. Stitch over with the sewing machine criss-cross at random until there are no empty spaces over 3 × 3cm (1¼ × 1¼in). Make absolutely sure that the lines of stitching are no closer or the item will become too stiff.
3. Put the shawl in the washing machine on a wool cycle at 30°C and spin at 1000rpm.

TIP

If you do not want the Crazy Felt look for this shawl, you can also hand-wash it. To do so, leave it in warm water for around half an hour. This makes it easier to wash and rinse out the item later on as the stabiliser and spray adhesive gradually dissolve.

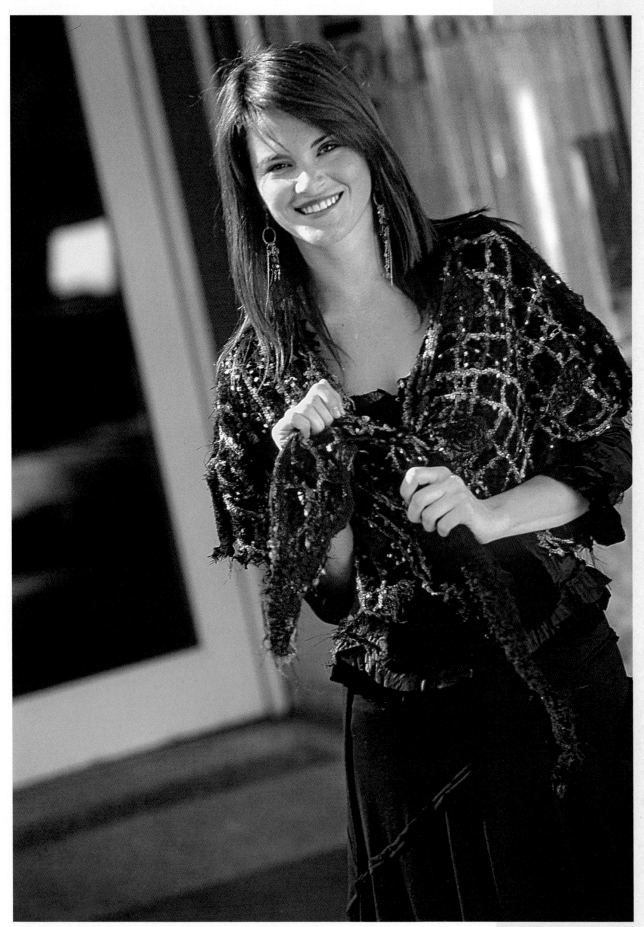

Beret
Page 10

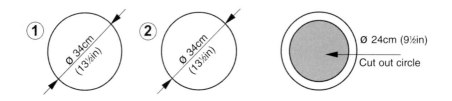

Denim skirt
Page 12

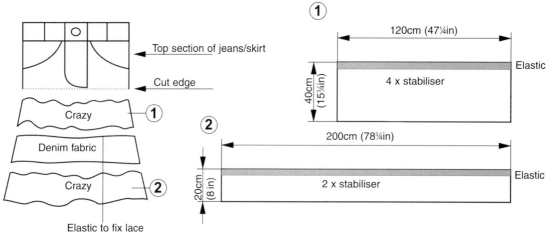

Denim bag
Page 12

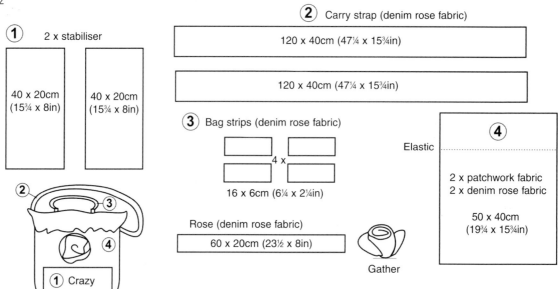

Cape

Page 14

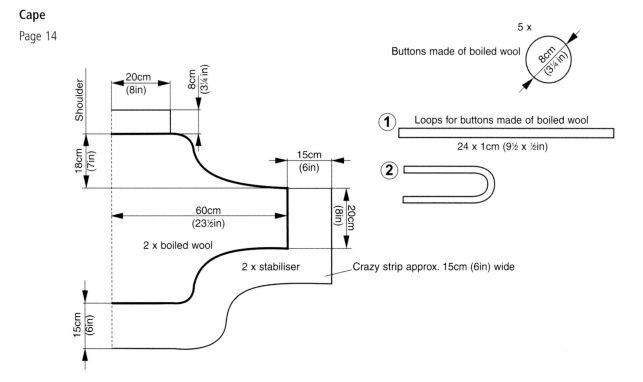

Shoulder

20cm (8in)

8cm (3¼in)

18cm (7in)

60cm (23½in)

2 x boiled wool

15cm (6in)

2 x stabiliser

15cm (6in)

20cm (8in)

Crazy strip approx. 15cm (6in) wide

5 x

Buttons made of boiled wool

8cm (3¼in)

(1) Loops for buttons made of boiled wool

24 x 1cm (9½ x ½in)

(2)

Belt

Page 16

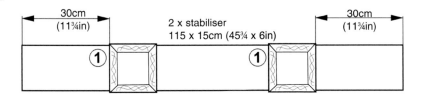

30cm (11¾in)

2 x stabiliser
115 x 15cm (45¾ x 6in)

30cm (11¾in)

(1) (1)

4 x stabiliser squares
16 x 16cm (6¼ x 6¼in)

(1)

Trimmed with lace

Bag

Page 16

2 x Patchwork fabric, 4 x stabiliser

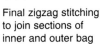

Final zigzag stitching
to join sections of
inner and outer bag

Fold of fabric

Total length 48cm (19in)

26cm (10¼in)

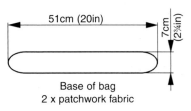

51cm (20in)

7cm (2¾in)

Base of bag
2 x patchwork fabric

Hat

Pages 16, 18, 34

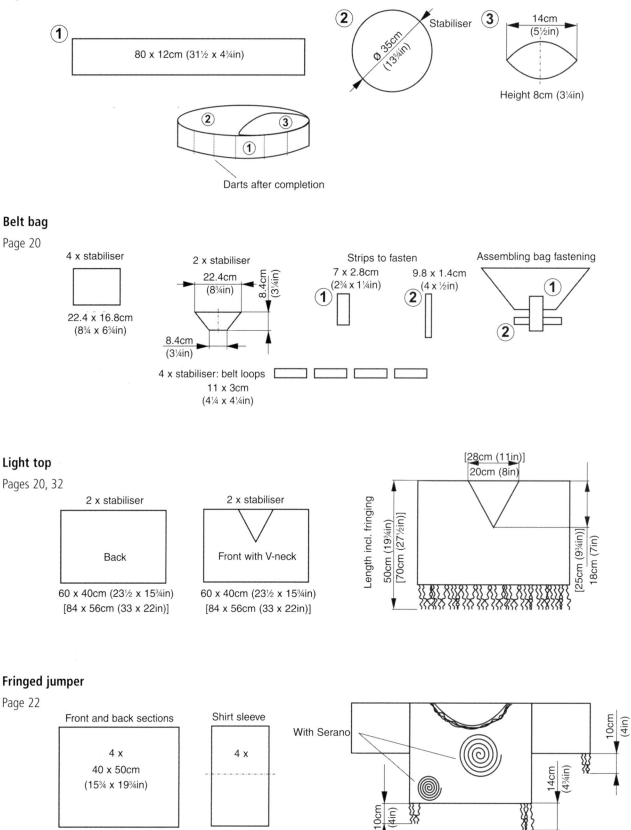

① 80 x 12cm (31½ x 4¾in)

② Ø 35cm (13¾in) — Stabiliser

③ 14cm (5½in) — Height 8cm (3¼in)

Darts after completion

Belt bag

Page 20

4 x stabiliser
22.4 x 16.8cm
(8¾ x 6¾in)

2 x stabiliser
22.4cm (8¾in)
8.4cm (3¼in)
8.4cm (3¼in)

4 x stabiliser: belt loops
11 x 3cm
(4¼ x 4¼in)

Strips to fasten
① 7 x 2.8cm (2¾ x 1¼in)
② 9.8 x 1.4cm (4 x ½in)

Assembling bag fastening
① **②**

Light top

Pages 20, 32

2 x stabiliser
Back
60 x 40cm (23½ x 15¾in)
[84 x 56cm (33 x 22in)]

2 x stabiliser
Front with V-neck
60 x 40cm (23½ x 15¾in)
[84 x 56cm (33 x 22in)]

[28cm (11in)]
20cm (8in)

Length incl. fringing
50cm (19¾in)
[70cm (27½in)]

[25cm (9¾in)]
18cm (7in)

Fringed jumper

Page 22

Front and back sections
4 x
40 x 50cm
(15¾ x 19¾in)

Shirt sleeve
4 x
24 x 40cm
(9½ x 15¾in)

With Serano

10cm (4in)
14cm (4¾in)
10cm (4in)

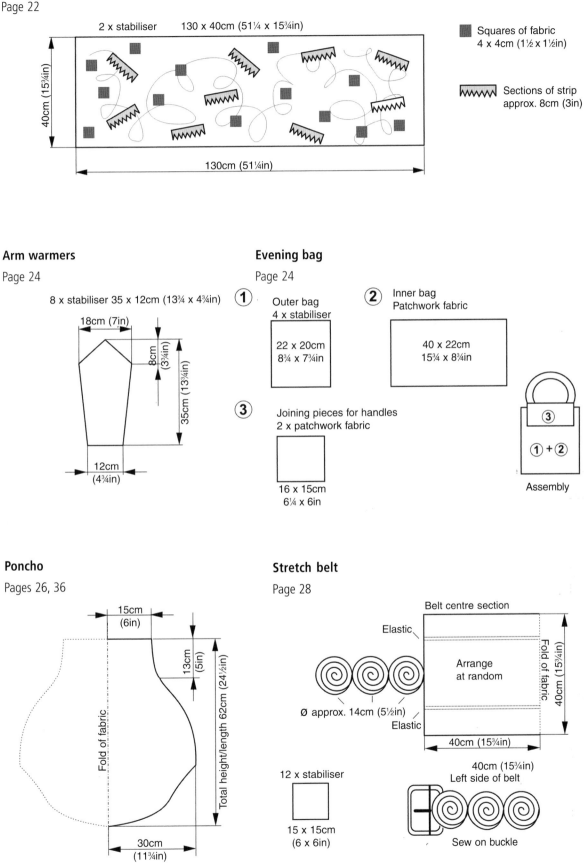

Fringed jumper

Page 22

2 x stabiliser 130 x 40cm (51¼ x 15¾in)

40cm (15¾in)

130cm (51¼in)

■ Squares of fabric
4 x 4cm (1½ x 1½in)

〜〜〜 Sections of strip
approx. 8cm (3in)

Arm warmers

Page 24

8 x stabiliser 35 x 12cm (13¾ x 4¾in)

18cm (7in)

8cm (3¾in)

35cm (13¾in)

12cm (4¾in)

Evening bag

Page 24

① Outer bag
4 x stabiliser

22 x 20cm
8¾ x 7¾in

② Inner bag
Patchwork fabric

40 x 22cm
15¾ x 8¾in

③ Joining pieces for handles
2 x patchwork fabric

16 x 15cm
6¼ x 6in

③

① + ②

Assembly

Poncho

Pages 26, 36

15cm (6in)

13cm (5in)

Fold of fabric

Total height/length 62cm (24½in)

30cm (11¾in)

Stretch belt

Page 28

Belt centre section

Elastic

Arrange
at random

Fold of fabric

40cm (15¾in)

Ø approx. 14cm (5½in)

Elastic

40cm (15¾in)

12 x stabiliser

15 x 15cm
(6 x 6in)

40cm (15¾in)
Left side of belt

Sew on buckle

Fluffy jumper

Page 30

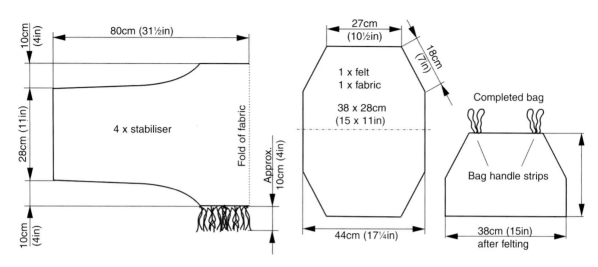

10cm (4in)

80cm (31½in)

28cm (11in)

4 x stabiliser

Fold of fabric

Approx. 10cm (4in)

10cm (4in)

Felt bag

Pages 30, 32

27cm (10½in)

18cm (7in)

1 x felt
1 x fabric

38 x 28cm (15 x 11in)

44cm (17¼in)

Completed bag

Bag handle strips

38cm (15in)
after felting

Scarf

Page 34

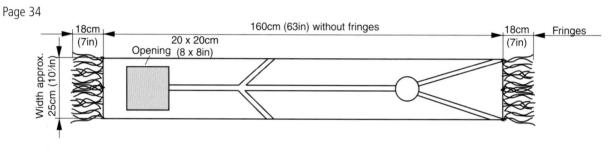

18cm (7in)

160cm (63in) without fringes

18cm (7in)

Fringes

Width approx. 25cm (10¼in)

20 x 20cm (8 x 8in)

Opening

Bolero

Page 38

60cm (23½in)

45cm (17¾in)

① 2 x stabiliser
Back
At random or pattern

Front

10cm (4in)

②

25cm (10in)

45cm (17¾in)

4 x stabiliser

30cm (11¾in)

③

20cm (8in)

35cm (13¾in)

Assembly

② Checks

Red felting wool

③

Stitched seam

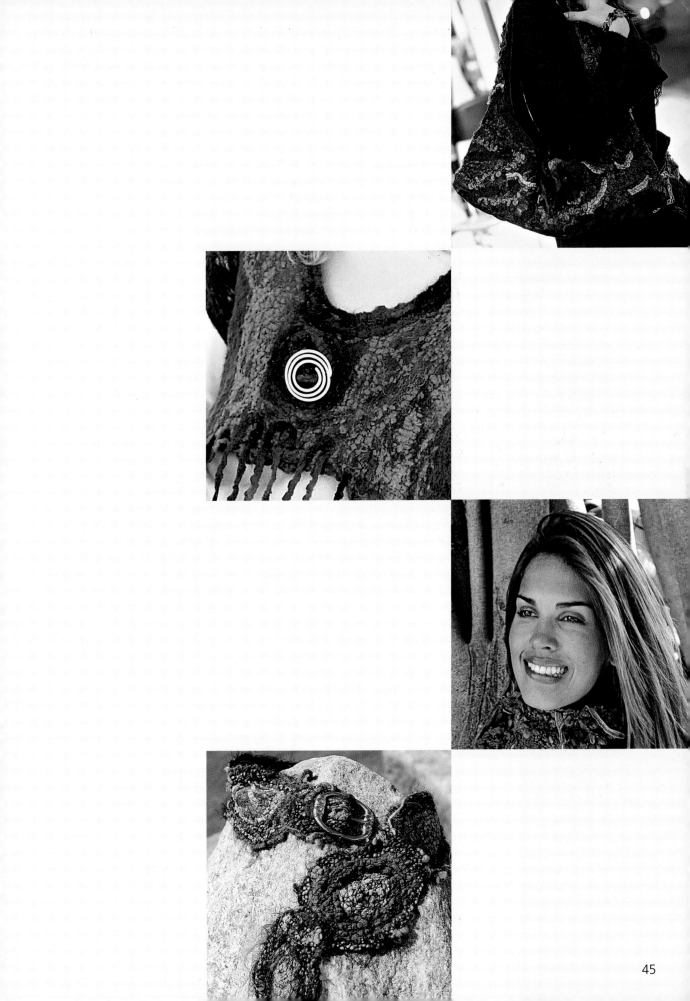

Vlieseline®
New vlieseline® Soluvlies

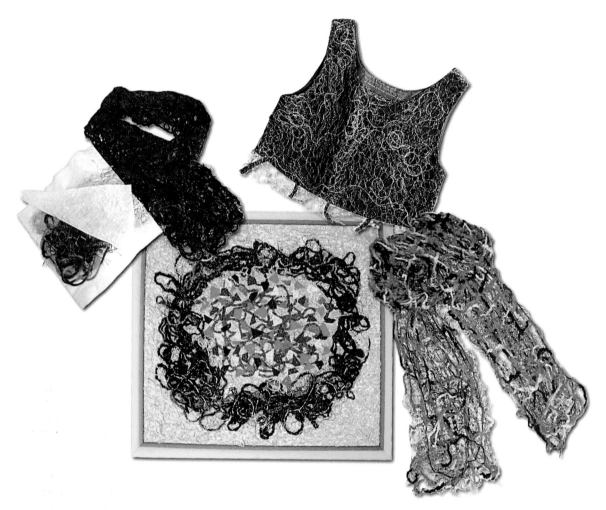

Dissolves in cold water
Stabiliser for handicrafts and embroidery

- Washes out in cold water
- Ideal stabiliser
- Suitable for very fine fabrics, freehand lace embroidery, appliqué and inset motifs
- Collages using special thread techniques
- Ideal aid when sewing mini-quilts

Freudenberg Vliesstoffe KG
Vertrieb Vlieseline
Hatschekstraße 11
69126 Heidelberg / Germany
www.vlieseline.de

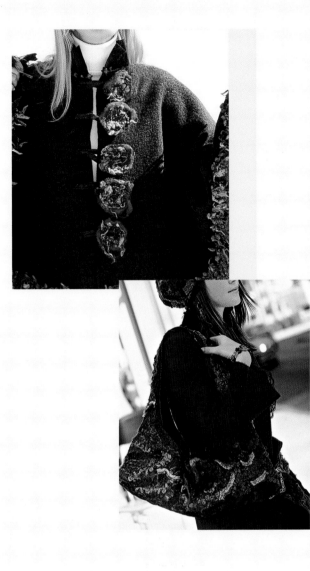

Acknowledgements

The author would like to thank these companies for their kind support:

Yarns:
Gedifra and Schachenmayr via Coats GmbH, Salach

Soluvlies:
Freudenberg Vliesstoffe, Heidelberg

Fabrics:
Zweigart & Sawitzki, Sindelfingen

Bag handles, spray adhesive and belt buckles:
Prym Consumer, Stolberg

Turbo-Filzer:
Coats GmbH, Salach

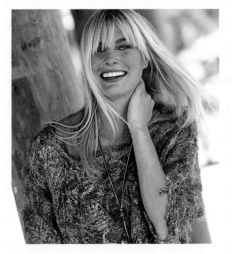

First published in Great Britain 2008 by Search Press Limited,
Wellwood, North Farm Road, Tunbridge Wells, Kent TN2 3DR

Originally published as *Crazy Filz* in Germany 2006 by OZ-Verlags-GmbH
Copyright © OZ-Verlags-GmbH, 2006
Rheinfelden
OZ creative publishers, Freiburg im Breisgau

English translation by Cicero Translations

English translation copyright © Search Press Limited 2008

English edition edited and typeset by GreenGate Publishing Services

ISBN: 978–1–84448–356–3

Designs and production:
Jeanette Knake

Photography:
Christine Rosinski
Frank Rabis (Pages 6–9)
Uwe Stratmann (Pages 8, 1/2)

Styling:
Birgit Hoheisel
Jeannette Knake (Pages 6–9)
Anne Pieper (Pages 8, 1/2)

Layout:
Dieter Richert, Freiburg/Cologne

Printed in Malaysia